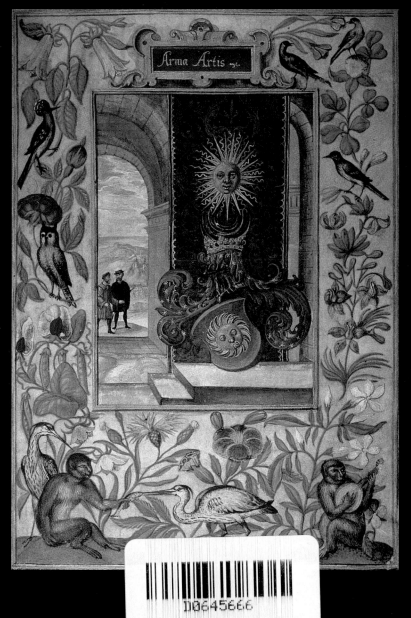

Arma Artis

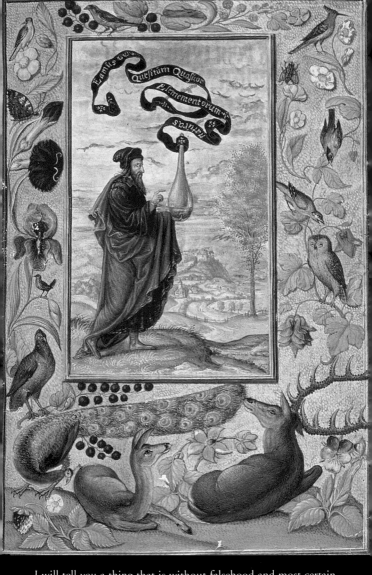

I will tell you a thing that is without falsehood and most certain.
That which is above is like that which is below, and that which is below
is like that which is above, working the miracles of the One

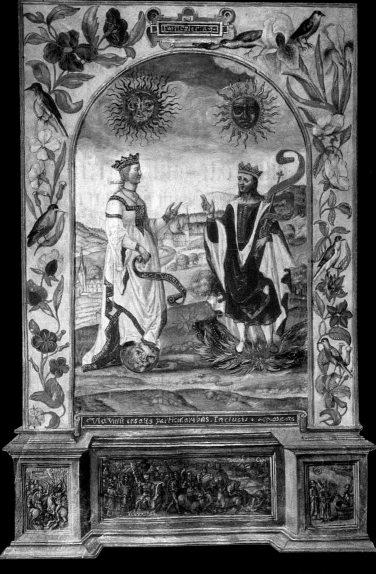

And since all things arise from the One by the work of the One,
so all things arise from this unique thing, by adaptation.

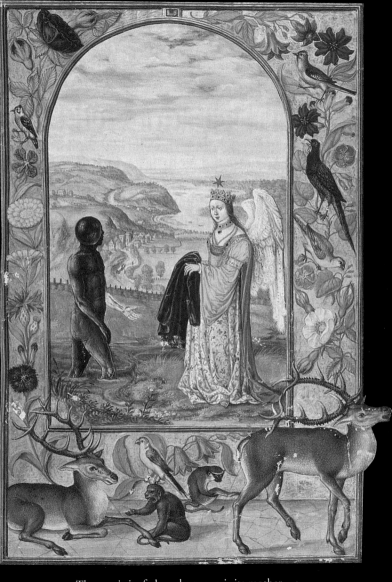

The sun is its father, the moon is its mother.
The wind carried it in her womb, the earth nourished it.

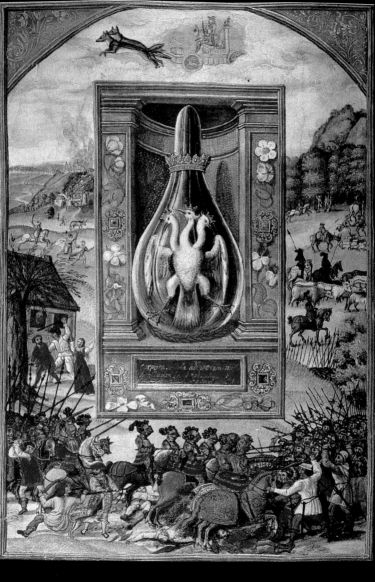

It is the principle of perfection throughout the world.
Its power is infinite when it is changed into earth.

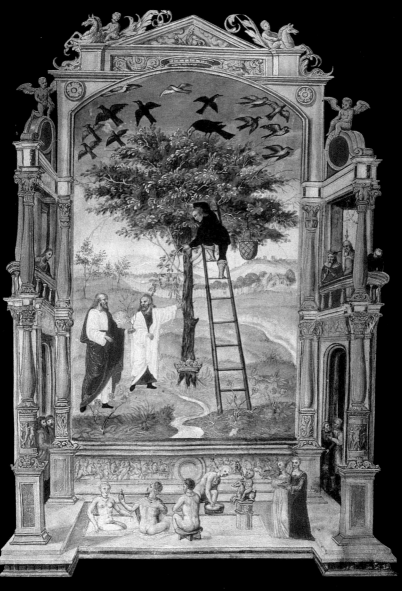

It ascends from earth to heaven and from heaven descends to earth, and
gathers the unity of the power of higher things and lower things.
Thus you will achieve glory throughout the world and you will ward off all shadows.

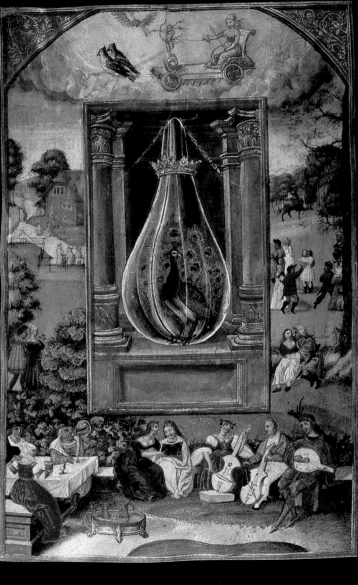

It will separate earth from fire, the thin from the thick,
gently, with great skill.

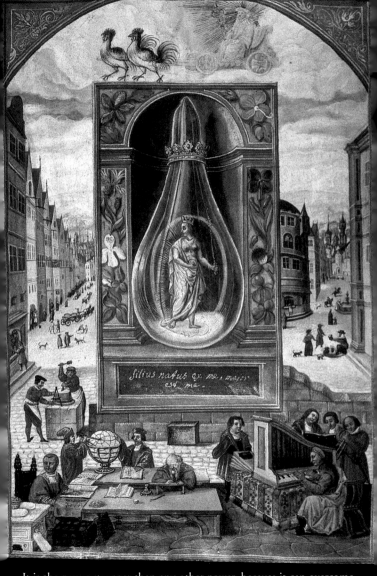

filius natus ex me, major est me.

It is the power stronger than any other power, because it can overcome every subtle thing and penetrate every solid thing.

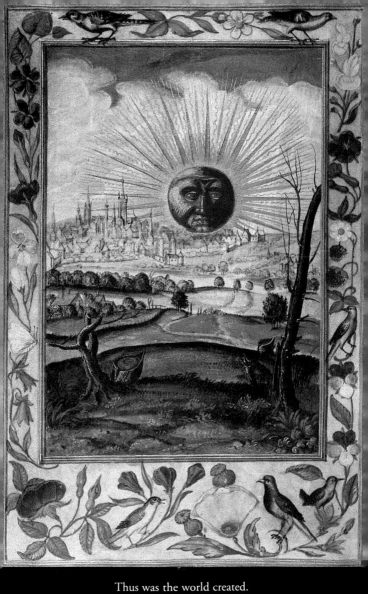

Thus was the world created.
Marvelous are the operations that have been accomplished in this manner.
And here ends what I must say about the work of the Sun.

CONTENTS

ALCHEMY
THE GREAT SECRET

Andrea Aromatico

DISCOVERIES®
HARRY N. ABRAMS, INC., PUBLISHERS

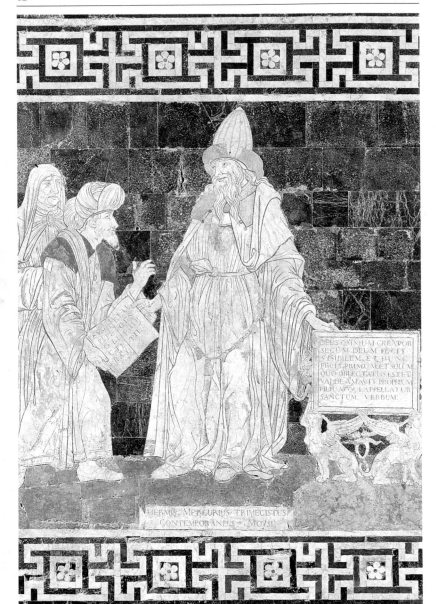

DEUS OMNIUM CREATOR
SECUM DEUM FECIT
VISIBILEM ET HUNC
FECIT PRIMUM ET SOLUM
QUO OBLECTATUS EST ET
VALDE AMAVIT PROPRIUM
FILIUM QUI APPELLATUR
SANCTUM VERBUM

HERMIS MERCURIUS TRIMEGISTUS
CONTEMPORANEUS MOYSI

In the labyrinth of time, alchemy appears as a chimera with vague outlines, a Fata Morgana whose diaphanous silhouette dissolves in the smokes and vapors that issue from the furnaces and alembics of sorcerers. The legends that surround it are innumerable, and verifiable facts are rare. What is alchemy? Who were the alchemists? Could they really turn lead into gold? What is the true nature of their arcane discipline?

CHAPTER 1

THE CONCEPT OF ALCHEMY

Left: in the inlaid pavement of the cathedral in Siena, Italy, eastern and western sages pay homage to Hermes. The conceptual system that defines alchemy and its symbolism was first constructed by the Greco-Egyptian philosophers of ancient Alexandria, who created the myth of Hermes that combined the initiatory wisdom of the East and the West. Right: two snakes entwined about a winged baton form the caduceus, or staff of Hermes, now a symbol of physicians.

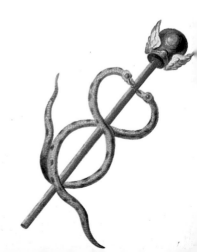

For as long as humanity has lived on earth we have questioned the meaning of our existence: why do we live and why do we die? Sciences and religions have sought to answer these questions in different ways: physics has developed in parallel with metaphysics; the one in the realm of research and observed data; the other in the realm of intellectual and spiritual speculation. But mysterious antique documents, some dating to ancient Egypt, suggest the existence of a third form of knowledge, one that dwells in the middle ground between the domains of fact and faith.

The first alchemistic texts

These texts appeared at around the same time in many of the world's most ancient cultures, in the East as well as the West. Inscriptions on parchment, papyrus, and clay tablets were found in Egypt, China, India, and Mesopotamia; later, Greek, Latin, and Arabic manuscripts also appeared.

Among these are the Arabic *Kitab Sirr al-khaliqa wa santat al-tabia* (*Book of the Secret of Creation and the Art of Nature,* also called the *Book of Causes,* whose author is said to be a certain Balinas), c. AD 650; the *Kitab Sirr al-Asar,* c. AD 800, a book of advice for kings and possible source of the *Emerald Tablet;* and a 4th-century Syrian Greek text by Bishop Nemesius of Emesa. In China, the *Book of the Nine Elixirs* (*Huangdi jiuding shendan jing*) and other texts appeared in the

The first known alchemistic documents share a distinctive feature, evidence, perhaps, of an older oral tradition: they rely greatly on graphic or visual symbols, with writing reduced to a minimum. From its beginnings, alchemy has cloaked itself in mystery, using arcane and secret language legible only to the initiated. Left: a cuneiform inscription from a fragment of an ancient Mesopotamian tablet.

first centuries AD. Such books spoke in obscure terms of infusing matter with spirit and rendering the spirit material, of the necessity of purifying the practitioner's nature, so that his or her substance could be purified, and vice versa. Some contained strange drawings, representing furnaces, instruments for distillation, and mysterious symbols with multiple meanings; they hinted that it was possible to learn the truth through secret, esoteric techniques.

Science, art, or religion?

Magic, philosophy, science—just what is alchemy? What was it originally and by what characteristics may we recognize it today? Its practitioners in medieval Europe called it an art, by which they meant something similar to a technology, or practical science. Alchemy (from the Arabic word *al-kīmiyā*, the Philosopher's Stone) is usually thought of as an early form of science with mystical and spiritual components. It was heir to the ancient techniques of mining, smelting, and smithery, which used fire to purify and alter the physical form of metal ores. These skills were practiced by religious masters who passed them down through secret rites. It was also the forerunner of chemistry and pharmacology.

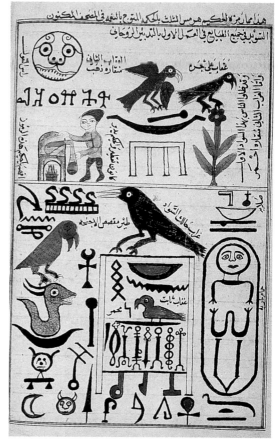

A page from an 18th-century edition of an older Arabic alchemistic treatise. Many of the same symbols are found in manuscripts from different periods and places: the crow, the snake, the rose, the eagle, and so on, all seem drawn from the same representational universe.

Its students sought to transmute metals, to cure diseases, and to achieve long life or even immortality, according to a complex system of ritual, symbolism, and research derived from Alexandrian Egypt and even older sources. It also contains elements of astronomy and astrology, gnosticism, and other religious traditions. At the spiritual level, alchemy, like other forms of esoteric or secret knowledge, has always been concerned with discovering prime truths about the nature and origins of the world. In practice, its particular goal is the transmutation of base metal into gold, through an elaborate, secret operation with many stages, known as the *opus magnum,* or Great Work. In the larger sense, alchemy is interested in what the material world is made of, and how materials alter and change from one form to another. While change is visible in organic materials, the alteration or transmutation of inert metals is more mysterious. Thus, for the alchemists, to discover how to change one metal into another was a means of learning the secret and spiritual nature of the material world. The gold they sought to render was not merely a source of wealth, but a metaphor for spiritual purity and a symbol of the sun, itself a prime symbol of the source of life.

Alchemy has been defined as the conjunction of four principles: that an intelligent will or conscious energy is at work in the origins of life and in its universal manifestations; that humans can attain physical immortality; that the world is subject to inviolable and ineluctable laws; and that the development of an advanced metallurgical technology is the key to understanding the nature of the world.

From the Far East to the West

There are references to what may be alchemistic practices in many early texts. Vedic and Buddhist texts from ancient India mention a "liquid which could turn bronze to pure gold." In his *Treatise on the Great Virtue of Wisdom,* the guru Nāgārjuna (fl. c. AD 150–250) lists four ways to achieve the transmutation of metals. According to some legends, alchemy was practiced in China as early as 4500 BC, and the Taoist

Ancient Egypt's high technical development, mysterious written language composed of tiny pictures, and enigmatic and symbolic religion led the West in the Middle Ages and Renaissance to consider it the cradle of all secret knowledge, and of alchemy in particular. The first alchemistic treatises do, in fact, come from Alexandria, in Hellenistic-era Egypt. Above: gold workers in an 18th-Dynasty Egyptian wall painting; above right: a page from a Greek alchemistic manuscript.

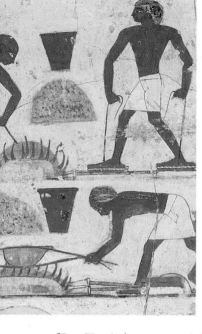

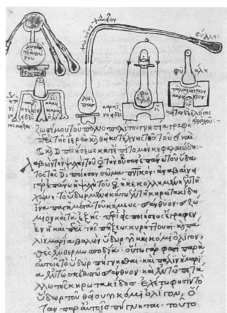

texts of Lao Tzu (6th century BC) describe a search for an elixir of long life that will lead humans to physical and spiritual perfection. For millennia, alchemy flourished in the valleys of the Nile and the Euphrates rivers, and the Aegean basin. The art of metallurgy in these regions reached a great level of refinement, and was closely allied to religious systems. Technology had no difficulty in gaining entrance to the temples in a time when the mysteries of the crafts were handed down from father to son and every activity partook of the sacred. Alchemy, descended from the guilds of smelters who guarded the secrets of the use of fire and metalworking, flourished in the temples of Egypt, Greece, and Mesopotamia; there, adepts could practice its secret rites and carry out its vocation to investigate nature. The early alchemists were probably both metal smelters and priests of the eternal fire, a caste dedicated to theurgic rituals. We should also remember a key

Test for the purity of gold

Remelt and heat it. If pure, it keeps its color after heating, and remains like a coin. If it becomes whiter, it contains silver; if it becomes rough and hard, it contains copper and tin; if it softens and blackens, it contains lead.
Leyden Papyrus X,
Egyptian, 3d century AD

figure in some African traditions: the shaman-craftsman who guides and directs initiation ceremonies. In some places, African shamans wore garb remarkably similar to that donned by the alchemist throughout the centuries.

Universal Mind

Underlying the practice of alchemy is the philosophical system called Hermetism, which draws elements from various religions and sciences, and is based mainly on the ancient writings ascribed to Hermes Trismegistus. Despite the ornate trappings of visual symbolism, secret rites, and metaphoric language that it accrued, its basic principle is disconcertingly simple: that every natural phenomenon—everything that exists, whether animal, vegetable, or mineral—has a single primary cause, or author. Alchemists call this principle "universal Mind"; it is, wrote Jean d'Espagnet, "diffused in the works of Nature as if by a continual infusion, and it moves each universal and each particular according to its nature, by means of a secret and perpetual act."

This principle of unity is difficult for our culture to grasp, for we live in a time in which knowledge is fragmented into discrete branches, divided and redivided into specialties and subspecialties. We are astronomers or physicians, chemists or biologists, doctors, philosophers, or literary scholars; the alchemists were all of these at once, and perhaps more. They considered nature to be a whole, and this is key to understanding the ways in which they attempted to penetrate its mysteries. Despite our distance from this way of thinking, alchemy's extraordinary, hyperbolic concepts may still transport us

"Hermes, he said, calls man the microcosm because man, or 'little world,' contains everything included in the macrocosm, or 'great world,'…the macrocosm [has] two sources of light, the sun and the moon; man also has two sources of light: the right eye, which represents the sun, and the left eye, the moon; the macrocosm has mountains and valleys: man has flesh and bones. The macrocosm has the heavens and the stars; man has a head and ears. The macrocosm has the twelve signs of the zodiac; and man also has them, from the tips of the ears to his feet, which we call Pisces."

Ms. CCXCIX,
Biblioteca Marciana,
Venice

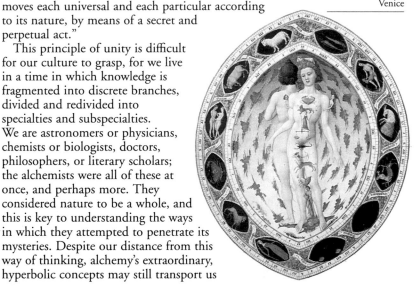

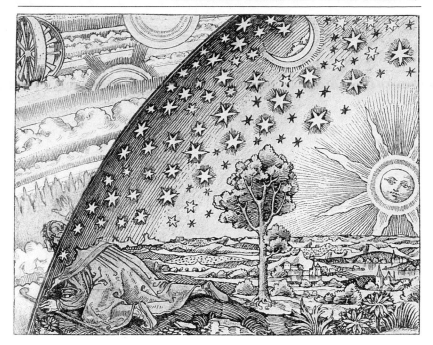

into a spiritual dimension that remains familiar to us, as we contemplate the chaotic vortices of human history, for it seeks the eternal path which the spectacle of the mysteries of creation provides for each individual.

In Hermetic philosophy, therefore, Mind is a whole, nature is a whole, and knowledge is one. However, this unified knowledge can only be perceived as a network of reciprocal sympathies which views everything in existence in relationship to everything else.

When the alchemists studied the transmutation of metals, or the nature and function of the celestial bodies, or any other subject, it was always with the primary goal of finding the means to resonate in harmony with universal Mind; the search for the Philosopher's Stone and other marvels was an attempt to give this research a concrete form.

But how could a simple human hope to absorb universal Mind? How might we entertain the possibility—

In this allegory, the seeker after knowledge breaks through the sphere of the sky, into the outer concentric spheres of the heavens. Metaphorically, the adept pierces the veil of appearances that conceals the mysteries of the secret celestial mechanisms by which all things were created from the One.

"One is the whole, and from this comes all, and in this is all, and if it does not contain the whole, the whole is nothing."

Chrysopeia of Cleopatra, anonymous manuscript, probably 10th or 11th century

even the faint possibility—of manipulating its imponderable energies, and putting them to our own uses?

The brotherhood of smelters

In many early cultures, metal smelters and other craftsmen worked within a religious context. For the ancients, the idea that all things are animated by a life energy whose origin is in a god or Prime Mover was fundamental. God thus gave concrete physical form to spiritual substance, and the entire universe is the union of the various aggregations that Mind, becoming matter, formed in the immanent world. Thus, no significant difference exists between heaven and earth, religion and philosophy, physics and metaphysics: all of creation is *unum in multa diversa moda,* one in many manifestations. All things live, grow, increase, and at the end of the cycle die, in order to come back again in a new transmutation.

Metal smelters, who transformed metals into new alloys and alloys into new forms, understood this. They were repeating on a small scale what God (or the gods) had done on a large scale. Alchemists drew on the same idea; it was their task to keep track of the steps by which they achieved each alteration and to relate them to those in nature. Here we must distinguish between this kind of research and the scope of the modern sciences: alchemy sought knowledge not only to understand matter, but to transcend it.

Hermes and the philosophers

The most important Hermetic texts on which alchemy was based are the so-called *Corpus hermeticum,* a collection of some fifteen (or seventeen) manuscripts, in the form of dialogues, probably written around AD 100–300. In one of the later of these, called the *Kore Kosmou (The Pupils of the World),* we find expressed for the first time a coherent description of the discipline's conceptual background. This became the ideological and spiritual foundation of alchemy. The texts on which it is based can be traced only through hints and fragments.

One probable source was the legacy of the classical Greek philosophers. Especially important to them were Pythagoras (c. 580–c. 500 BC), Democritus (c. 460–

Above: an image, from a 16th-century manuscript, of the Tree of Knowledge as a crowned woman, flanked by the sun and moon: Mother Nature alone dispenses wisdom to the initiates and frees the operations of the

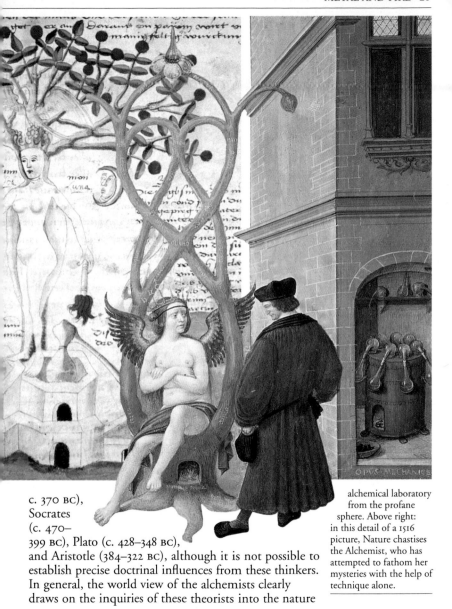

c. 370 BC),
Socrates
(c. 470–
399 BC), Plato (c. 428–348 BC),
and Aristotle (384–322 BC), although it is not possible to
establish precise doctrinal influences from these thinkers.
In general, the world view of the alchemists clearly
draws on the inquiries of these theorists into the nature

alchemical laboratory
from the profane
sphere. Above right:
in this detail of a 1516
picture, Nature chastises
the Alchemist, who has
attempted to fathom her
mysteries with the help of
technique alone.

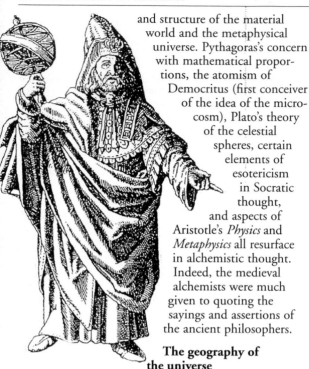

and structure of the material world and the metaphysical universe. Pythagoras's concern with mathematical proportions, the atomism of Democritus (first conceiver of the idea of the microcosm), Plato's theory of the celestial spheres, certain elements of esotericism in Socratic thought, and aspects of Aristotle's *Physics* and *Metaphysics* all resurface in alchemistic thought. Indeed, the medieval alchemists were much given to quoting the sayings and assertions of the ancient philosophers.

The geography of the universe

The method of alchemy sought to mimic that of the creation of the universe—the macrocosm—and to that end developed a concept of the origins, nature, and structure of the universe: its cosmogony and cosmology. We must not undervalue these today, however far they may be from the scientific ideas that govern our thought at present. The refined knowledge of the ancients was founded on a belief in an immense, reciprocal love of nature and all of creation, an idea that still commands respect.

What was this conception of creation? Beyond the basic notion of the oneness of Mind, a key element of the Hermetic world view is the concept of the mirror image—described in the *Emerald Tablet*—that links the high and the low. Everything that rules in the highest strata of existence is in correspondence with

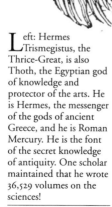

Left: Hermes Trismegistus, the Thrice-Great, is also Thoth, the Egyptian god of knowledge and protector of the arts. He is Hermes, the messenger of the gods of ancient Greece, and he is Roman Mercury. He is the font of the secret knowledge of antiquity. One scholar maintained that he wrote 36,529 volumes on the sciences!

the lower levels, and vice versa. Further, like some other ancient cosmologies, the universe of the alchemists is organized in a series of concentric spheres, the outermost of which is the macrocosm of the planets and the stars. The macrocosm's pattern rules the microcosms, each of which is a replica of it in small, reproducing its structure.

Alchemists called themselves "philosophers," and classed the learned men of the past as "masters of the Doctrine." Left: the sun and moon, alchemical symbols; below: a Renaissance painter imagines the wise men of old.

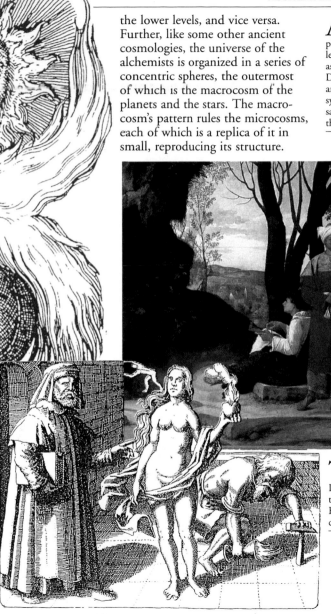

The classical Greek philosopher Democritus confronts the mysteries of ancient Egypt in this 17th-century print.

These are all interlinked. Beyond all is the divine firmament.

The world is, on the one hand, a microcosm of the universe and, on the other, a macrocosm of the single human being. The mineral kingdom is another such microcosm. By studying the world of metals and discovering its secrets, human beings arrived at knowledge of both the individual self and, by extension, the whole.

Humanity is considered first among the orders of living things, the most perfect bearer of the universal spirit, whose origin is divine. Through the spirit, God created the universe, and concentrically within it, the world and humanity; humans, by their intellective faculty, are able to understand the mechanisms of creation, the laws that have organized existence since the original, primordial, lifeless chaos. The Hermetic alchemists, therefore, took an approach analogous to that of the Demiurge who had animated the cosmos through an infusion of spirit: through their operations they attempted to create the world in microcosm.

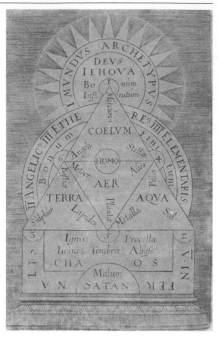

The difference between a traditional cosmology, such as that of Hermetism, and the modern conception of the analytic sciences appears clearly in their contrasting understandings of astronomy. The alchemists accepted the ancient view of the cosmos. In its earliest form, it placed the earth, a flat disk, at the center of the universe, overhung by the starry vault of the heavens. To this structure they assigned a profusion of meanings. In the 2d century AD, Ptolemaic astronomy improved on this ancient cosmology. It saw the earth not as a flat disk, but as a sphere around which the planets circled in their separate orbits, surrounded in turn not by an arch of stars but by the spherical heaven of fixed stars,

Medieval and Renaissance alchemistic treatises are full of synoptic diagrams that illustrate the cosmological and metaphysical conceptions of Hermetism. This one, by the alchemist Lambsprinck, places Evil, *Malum*, at the bottom of a geometric hierarchy that culminates with God, *Deus Iehova,* and Good, *Bonum Infinitum,* within the sun.

beyond which was the starless firmament, the divine limit. For the alchemists, Ptolemy's conception did not fundamentally alter the ancient vision of the world. They believed that it was accurate, based on their experience of nature as they observed it, but they were more concerned with the ways in which it could reveal the methodology proper to alchemy. They therefore introduced into this view of nature many ideas of their own, such as that of the primal balance between opposing forces.

The male and female principles are just one of numerous pairs of opposites-in-affinity that alchemy united in the magisterium of sulphur and mercury. The occult writer Titus Burckhardt wrote in 1960, "Heaven, which by its movement measures time in nature, which determines the seasons and the day and night, which makes the stars appear and disappear and spreads the rain, represents the active and masculine pole of existence. The earth, which, in response to the celestial influx, is impregnated and produces plants and nourishes all living beings,

The medieval West produced many parables and legends that recount the origin of the *Emerald Tablet*. In one version, a monk finds it in a pyramid guarded by eagles.

Phœnix

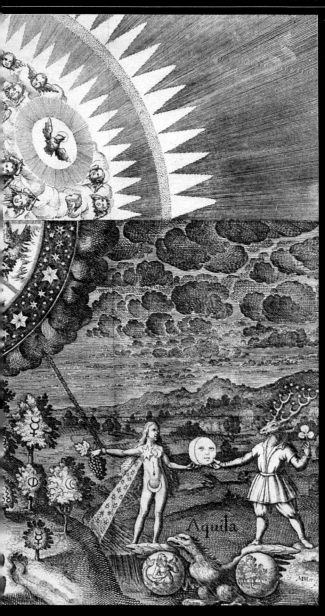

This allegory illustrates the elements of the Great Work and the correspondences between microcosm and macrocosm in the Hermetic universe. The alchemist, standing on the ground at center, is initiated into the secrets of day and night, represented by his robe. To his right, in sunlight, are the masculine principles of the alchemical Work: the lion, sun, man, phoenix, and terrestrial fire. The feminine principles are to his left, plunged in evening shadow: the moon, a woman whose breasts dispense the vital fluid of life, eagle, and spring of pure water. At far left is the deer-headed hunter Actaeon of Greek myth, who sees Diana (the moon goddess) naked, and is transformed. The trees that surround the alchemist represent the metals, each with its symbol. Above him are concentric spheres of alchemical knowledge: the firmament and the animals that symbolize the stages of the Work: the crow of putrefaction, the ostrich of calcination, the mercurial dragon, the pelican of absorption, the phoenix of the Philosopher's Stone. At top are the symbols of the Holy Trinity. At center is the diagram of alchemical knowledge in the form of an armillary sphere, with rings for the signs of the zodiac, the wind, sun, and stars, and the metals.

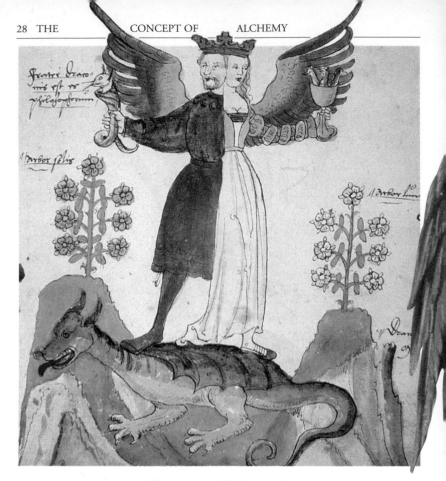

represents the passive and feminine pole." Reunited by the *coincidentia oppositorum,* the conjunction of opposites, such complementary pairs are symbolically represented by the Rebis, or twofold substance; by the philosophical egg; and by the hermaphrodite, who is both male and female.

In fact, the Ptolemaic cosmological model confirmed two premises of Hermetism. First, it affirmed the concentric and sympathetic organization of space. Second, it confirmed a core idea of the alchemists: that knowledge exists on two levels, the spiritual and the

Above, right, and opposite: the figure of the androgyne, or hermaphrodite, half man and half woman, is one of many symbolic images in alchemy that represent the union of opposites. In such images, myriad meanings coexist within a single representation; conversely, a single image also suffices to express all of alchemy.

material (or terrestrial), one above the other. According to this vertical system of knowledge, each perceptible element on the earthly level symbolically represents or reveals corresponding elements in the higher realm.

Was alchemy disrupted by the revolutionary discoveries of Copernicus (1543), whose astronomical observations placed the sun at the center of the planetary system? Not at all! Hermetic philosophy adapted this new order and saw God as the fixed center of the universe, the Light of which the sun had always been the symbol. Beyond this, the Copernican view of the solar system in no way altered the main point: that the role of human beings as bearers of special knowledge had been conferred by their Creator. On the contrary: it linked humankind all the more strongly to this illuminating sun, whose origins remained divine and which was the source of all things and the end to which all, by a circular path, must eternally return.

This observation leads us to consider the alchemists' conception of time. Working from this model of the system of space as a set of concentric spheres, they conceived of time as equally circular in structure—or,

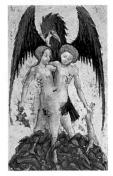

The principal goal of the Great Work of alchemy is the union of opposites, the harmonious resolution of antinomic pairs into a third thing that both partakes of their original natures and is something new. The adepts called this entity Rebis, the double: material that is at once twofold and unified. The Rebis is the resolution of all dialectics in harmony. It is often represented as a hermaphroditic figure, a new being created by the conjunction of art (technical mastery) and spirit (insight).

to be more precise, cyclical. Certain truths, certain forms of knowledge are from the outset beyond time, eternal and unchangeable. Like the spheres of the earth and the heavens, the temporal macrostructure as well as its microstructures obeyed the same laws of circular development: world history began with an ancient golden age, followed by a decline or collapse, a slow development of a new age of humanity, striving toward a new golden age in an unending cycle. The space-time of alchemy does not follow a linear progression (from the birth of the universe toward a single future apocalypse), but rather continually turns in upon itself, always pregnant with the universal spirit. Its coordinates are divine will and human destiny, and all the beings of creation pursue their existence according to this structure. The ancient symbol of Ouroboros—the snake that holds its tail in its mouth, an image dear to alchemists—signified this circular universe, as well as the more basic and unquestioned concept of the unity of matter.

The consequences of this idea are immediate. While profane science, by nature curious about the endless multiplicity of phenomena, generated more and more experiments and explanatory models (and, victim of its own energies, split into a thousand specialized branches as it advanced), alchemy remained a single unified, organic discipline. For the alchemists were animated by a quest for sacred awareness, for the spiritual center of the material world.

A lchemical conceptions were untroubled by the increasing refinement of scientific knowledge, which led to the succession of astronomical models: the immanent had no purpose for them other than to provide a symbolic foundation for a transcendent knowledge. Flat, round, or elliptical: the shape of the earth mattered little, since it had to be abandoned in order to reach a higher sphere. Below: Hieronymus Bosch's 1503–4 painting of the creation of the world, imagined as a sphere.

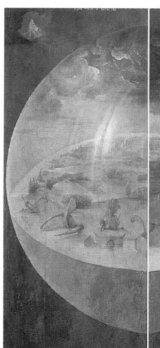
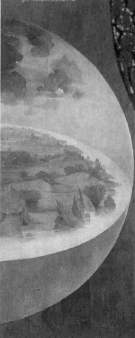

The snake Ouro-
boros, emblem of
alchemy, is a symbol
of eternity and
regeneration.

Matter, spirit, the elements, the metals

What we mean today by the word *matter,* or
material, does not correspond to what the term
originally meant in Hermetic philosophy. In the
alchemical conception, the material is mingled with the
spiritual. Matter and spirit are the two poles, active and
passive, between which migrates all that exists. For the
spirit to be made manifest requires a material support,
and matter exists only thanks to some component of
spiritual nature.

Upon this idea, alchemy developed a theory of the
elements that drew heavily on the ancient teachings of
Aristotle. The fundamental archetypal elements are
four in number: earth, air, fire, and water, each of
which has distinct and
unique qualities
(Aristotle

It repre-
sents the
heart of
Hermetic philos-
ophy, according to
which each thing is
linked to the whole,
matter and spirit are one,
the manipulation of
them can work wonders,
and the transmutation of
materials is possible.

calls them fluid or moist, dry, hot, and cold). These
elementary qualities are present in every material thing,
in mixtures and proportions prescribed by the Creator.
A fifth, ultimate essence dominates the four, and stands,
near perfection, at the natural center of the spirit. This
is the quintessence.

Beneath this principal level, alchemy divides the material world according to a secondary structure. The metals are seen as the realm, or microcosm, closest to that of the human, and this realm is divided into seven categories, those of silver, mercury, copper, gold, iron, tin, and lead. Each of these metals represents an archetypal principle in the upper realm of the spirit that corresponds to its intrinsic metallic qualities in the lower, material realm. Therefore, alchemy is especially concerned with the study of metals—their composition and properties. Following the law that states that what is below is like what is above, these seven metals are each aligned with corresponding celestial bodies: the sun, the moon, and the five planets visible to the naked eye: Moon = silver, Mercury = mercury, Venus = copper, Sun = gold, Mars = iron, Jupiter = tin, Saturn = lead.

Alchemy had a fascinating theory about the origins of the seven metals, which were thought to grow in the womb of Mother Earth. "All temporal things derive their origin, their existence, and their essence from the earth, according to the succession of time," states a 1423 text called *A Tract of Great Price Concerning the Philosophical Stone: The True Teaching of Philosophy Concerning the Generation of Metals and Their*

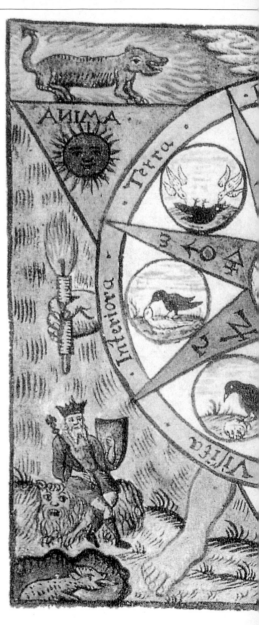

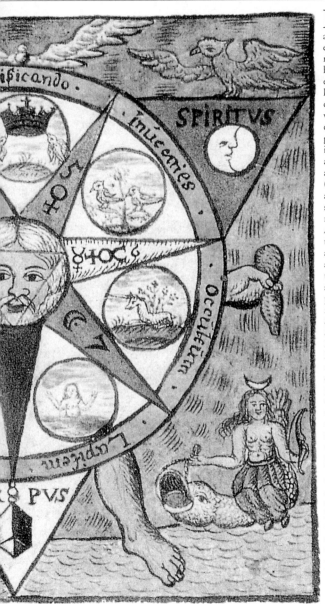

In the outer corners of this synoptic diagram are symbols of the four elements: a burning salamander (a creature said to have power over fire); an eagle, representing air; a king seated upon a lion, dominating the dragon who dwells within the earth; and the moon goddess Artemis, bestriding a sea creature. In the angles of the inverted triangle, the trinity of soul (*anima*), mind (*spiritus*), and body (*corpus*) is symbolized by the sun, the moon, and a stone weight. At center is the symbol of the origin of the world: an inverted triangle within a circle. The seven rays that emanate from it bear symbols of the seven planets of the alchemical metals: Jupiter/tin, Saturn/lead, Mars/iron, Sun/gold, Venus/copper, Mercury/mercury, and Moon/silver. Between the rays are allegorical scenes of the seven operational phases of the Great Work, of transmutation. The circumference expresses an occult meaning of the acronym VITRIOL, one of the chemical substances used to transform metals. The whole is also a figure of the body of an alchemistic adept: the center contains his face; his hands hold alchemical instruments, and, like the angel of *Revelations,* his feet rest upon earth and ocean.

True Origin. "Their specific properties are determined by the outward and inward influences of the stars and planets (such as the Sun, the Moon, etc.), and of the four qualities of the elements. From these combined circumstances arise the peculiar forms, and proper substances, of all growing, fixed, and generating things, according to the natural order appointed by the Most High at the beginning of the world. The metals, then, derive their origin from the earth, and are specifically compounded of the four qualities, or the properties of the four elements, their peculiar metallic character is stamped upon them by the influences of the stars and planets." Many alchemical manuscripts explore the relationship of the metals to the planets. "Alchemy," writes Franciscus Mercurius van Helmont in a 1687 text called *One hundred fifty three chymical aphorisms,* "is the perfect knowledge of whole Nature and Art, about the Kingdom of Metals...Alchymy...is a Science whereby the Beginnings, Causes, Properties, and Passions of all the Metals, are radically known; that those which are imperfect, incompleat, mixt and corrupt, may be transmuted into true Gold. The Matter of Metals is either remote or proximate. The Remote is the Rayes of the Sun and Moon, by whose Concourse all Natural Compounds are produced. The Proximate is Sulfur and Argent-vive, or the Rayes of the Sun and the Moon determined to a Metallick Production, under the form of certain humid, unctious, and viscous Substance."

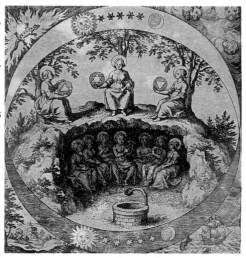

In this 17th-century print, the metal ores are represented as seven women.

Alchemy thus draws upon astronomy, astrology, and the early medical science of humors or tempers, as well as on Hermetic philosophy itself, for its organizing principles. In alchemy, the correspondence between earth and heaven, the lower and the higher realms, is cemented with unbreakable, secret, sympathetic, and reciprocal ties.

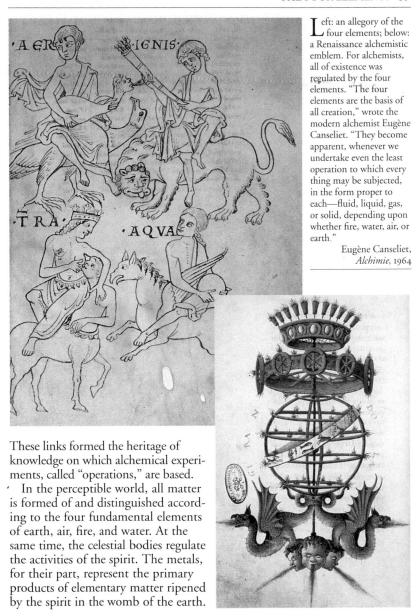

*L*eft: an allegory of the four elements; below: a Renaissance alchemistic emblem. For alchemists, all of existence was regulated by the four elements. "The four elements are the basis of all creation," wrote the modern alchemist Eugène Canseliet. "They become apparent, whenever we undertake even the least operation to which every thing may be subjected, in the form proper to each—fluid, liquid, gas, or solid, depending upon whether fire, water, air, or earth."

Eugène Canseliet,
Alchimie, 1964

These links formed the heritage of knowledge on which alchemical experiments, called "operations," are based.

In the perceptible world, all matter is formed of and distinguished according to the four fundamental elements of earth, air, fire, and water. At the same time, the celestial bodies regulate the activities of the spirit. The metals, for their part, represent the primary products of elementary matter ripened by the spirit in the womb of the earth.

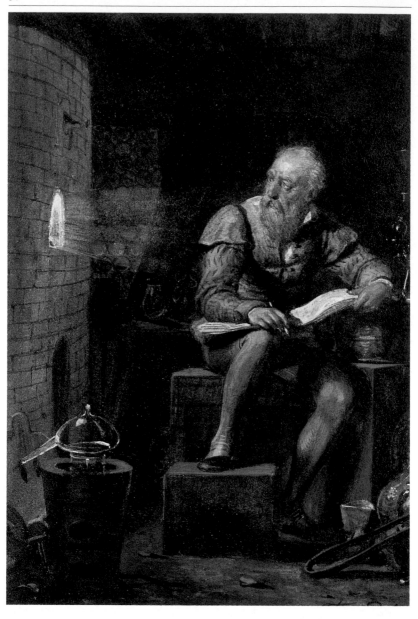

Hermetic philosophy provided the conceptual foundation upon which alchemy built its view of the universe. Having accepted the idea of the unity of matter, and therefore of the material and spiritual worlds, alchemists believed that it would be possible to identify the nature of all the elements through experimentation, and to bring about their transmutation. Thus were the first alchemical laboratories born.

CHAPTER 2
THE THEORY OF ALCHEMY

The light that shines from the furnace is, ideally, the same light that illuminates obscure meanings in the treatises. In this way, theory and practice are inextricably linked in the alchemist's Work. It could not be otherwise in a discipline like alchemy, which has as its final aim the reconciliation of all dualities and the unitary development of all knowledge. Left: a 19th-century image of an alchemist; right: an intricate alchemical diagram from 1696.

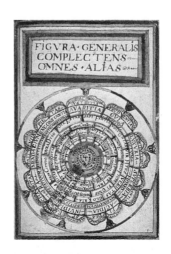

FIGVRA · GENERALIS
COMPLEC TENS
OMNES · ALIAS

To define the cosmological and cosmogonic ideas that formed the theoretical foundation of alchemy was only the first task. To develop a system of experimentation—of scientific research—came next.

The *prima materia*

Psychoanalysts such as Carl Gustav Jung and many historians of religion and the occult have explored alchemy as an esoteric search for the spiritual; historians of science have seen it as a first attempt at understanding

The Renaissance artist Albrecht Dürer imagines Melancholy personified as a philosopher or alchemist devoted to contemplation and research, to freeing knowledge from the tyranny of time and the finite world. Gathered about the dark angel are many resonant symbols: the burning crucible, the ladder of wisdom, the hewn stone, the oil lamp, instruments of geometry, the hourglass, the fiery wheel, the scales representing balance, the compass representing measure, the sphere, the key to wisdom. Melancholy was related to the planet Saturn and the saturnine emotion, or humor. Many representations of the temperaments in the Renaissance were based on alchemical symbolism.

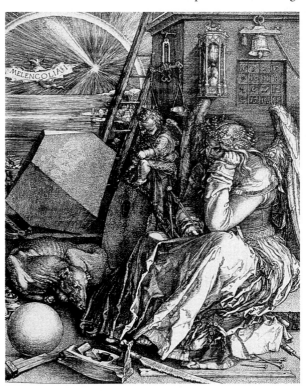

chemistry and physics. In truth, alchemists did not distinguish between these two endeavors. They were trying to achieve a single practical result: to find the animating material at the core of all life, and to command the mechanism whereby it worked. If, as Hermetic philosophy taught, a universal, intelligent spirit existed—a vital foundation for

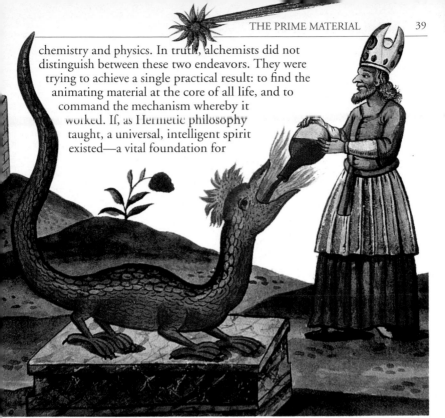

all the manifestations of life—then to discover it would be to govern life itself. To quote the 17th-century alchemist Baron Clovis Hesteau, Sieur de Nuysement: "A particle of this spirit, of celestial origins, taken whole, has more effect that a potful of medicine."

To the alchemists, all material substances were composed of varying proportions of the same basic essences. The universal spirit, fiery in substance and by nature all-powerful, was the primary agent—the *prima materia*—of all of the transformations in creation: the birth, growth, death, putrefaction, and reconstitution of all living things, whether plant, mineral, or animal. It granted the power to change any body into another—that is, to bring about its transmutation. The aim of the alchemists was to discover or render concrete this sacred spirit; transmutation

The alchemist—scientist, priest, and magician—is guided by a star, as were the three kings to Bethlehem. He feeds the dragon (symbol of fire and primal chaos) with spiritual substance to quench its flames and purify its shadowy nature, readying it for future manipulations. "Look well at these two dragons," wrote Nicolas Flamel in the Middle Ages, "...the one which is below without wings...is called Sulfur, or heat and dryness."

of one metal into another was the confirmation of the deeper goal. To transform base metal into the purest of all metals, gold, was the proof the alchemists needed.

The alchemical vessel

Despite many detailed medieval and Renaissance texts describing the furnaces and tools, the chemicals and processes by which the Great Work of transmutation was carried out, the actual operations remained secret, hidden within dense allegorical language. Using fire as well as acids and other reagents, a metal or other material was subjected, in various stages, to chemical treatments. According to Athanasius Kircher's *Mundus subterraneus,* 1665, these included putrefaction, coagulation, calcination, fixation, solution, digestion, distillation, sublimation, multiplication, and projection; other texts mention mortification, conjunction, dissolution, corrosion, ignition, precipitation, liquefaction, purification, exaltation, reduction, and numerous other terms. "To dissolve is to make the gross subtle; to purify is to make the dark bright; reduction is of the humid into the dry; fixation is by resolution and coagulation of the spirit into its own body, or solid substance," wrote Arnau de Vilanova in the *Rosarium philosophorum,* c. 1505. The progressive stages, or operations, each had a name and its own set of arcane practices, laden with allegorical meanings.

A literal and figurative problem the alchemists confronted was to find a container capable of receiving the *prima materia* and preventing its escape. What vessel—to use the preferred term—could contain this powerful essence while operations of distillation, purification, and transmutation were performed upon it? And once the operation was complete, how could it be hermetically sealed so that its precious contents could not escape back into the ether? Vessels of glass, metal, and other materials were used for various processes. But it is important to remember that the vessel of the Great Work may be understood not only as a literal alembic or retort in a laboratory, but also symbolically, as the crucible in which the soul of the knowledge seeker is transformed.

In addition to the vessel, the alchemist also required the proper catalyst for the transformation of the spirit. This

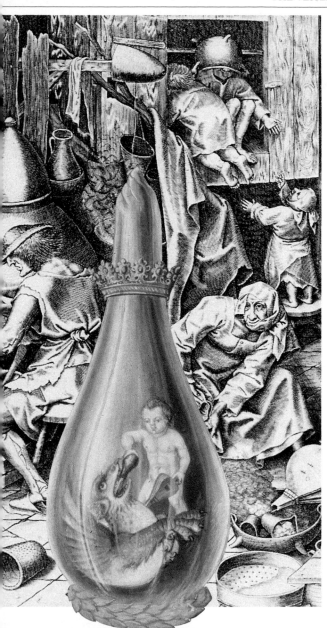

"All the Philosophers teach [these things], except the Vessel of Hermes, because it is divine, and of the Wisdom of the Lord hidden from Nations: and they who are ignorant of it, know not the Regimen of Truth, because of their Ignorance of the Vessel of Hermes."

The Practise of Mary the Prophetesse in the Alchymicall Art, 17th century

The treatises of the alchemist Morienus (said to have lived in the 5th century) and the Arab Hali are known through references in later texts. Both wrote on the vessel and other arcana. In the former, we read, "If the ancient sages did not find the quantity of the vessel, in which our stone will be placed, they would never have arrived at the perfection of this magisterium." The latter writes, "Know the measure or the degree of the vessel of our work, because this vessel is the root and the principle of our magisterium. And this vessel is like the womb among animals, because in it they engender, conceive, and also nourish generation. For this, if the vessel of our magisterium is not suitable, the entire work is destroyed; our stone will not produce the effect of generation, because it does not find the vessel suitable for generation."

was known as the magisterium, or philosopher's lodestone. Depending on the particular process, it might be magnetite, an iron ore with metal-attracting powers, or another mineral, such as sulphur or mercury.

What were the processes of alchemy? Many were those of metallurgy and chemistry, raised to the level of occult art: amalgamation, the making of alloys; cineration and assation, the reduction of a substance to ash; coagulation, the thickening of a thin liquid, as by curdling; corrosion, the reduction of a metal by use of acid or alkali, and so forth. Much of the inner meaning of these procedures was secret, but the goal was always the conversion of metal into a purer form and the conversion of the practitioner into a purer self.

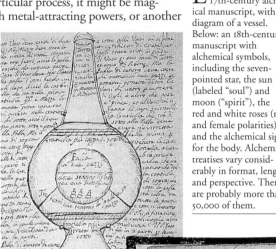

The treatises

Where was the information preserved for those who wished to learn these techniques? Some was handed down directly from master to apprentice, but much was recorded in books. Alchemical treatises written before 1800 number in the thousands. How can this be, when the science itself so desired to remain secret? The secrecy at the heart of alchemy is not due to a wish to prevent the growth of knowledge, but is based on the idea that knowledge itself has a mysterious

L eft: a page from a late 17th-century alchemical manuscript, with a diagram of a vessel. Below: an 18th-century manuscript with alchemical symbols, including the seven-pointed star, the sun (labeled "soul") and moon ("spirit"), the red and white roses (male and female polarities), and the alchemical sign for the body. Alchemical treatises vary considerably in format, length, and perspective. There are probably more than 50,000 of them.

nature, particularly the self-knowledge that is the aim of the adept. Indeed, alchemy imposes a unique ethical commitment upon its disciples: the alchemist is enjoined to be both *charitable* and *envious*— that is, to share the science's material gifts and wisdom, but also to prevent the vulgarization of its principles and techniques through indiscriminate disclosure of its art.

This was the double aim of the treatises: they gave

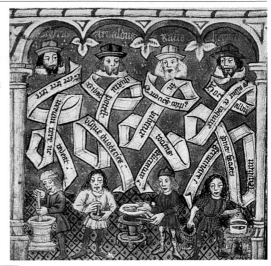

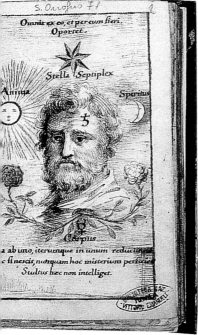

practical instructions in the art and science of transmutation and related matters, but expressed their concepts in an arcane, spiritual language designed to separate the worthy from the unworthy, so that only a student with a sincere vocation could attain true understanding. Thus, these treatises contain long passages of obscure metaphysical speculation, cosmological and cosmogonic description, and mystical allegory. The aim of these is to

"In many ancient Books there are found many definitions of this Art... Alchemy is a Corporal Science simply composed of one and by one, naturally conjoining things more precious, by knowledge and effect, and converting them by a natural commixtion into a better kind...Alchemy is a Science, teaching how to transform any kind of metal into another: and that by a proper medicine, as it appeared by many Philosophers' Books. Alchemy therefore is a science teaching how to make and compound a certain medicine, which is called Elixir."

Roger Bacon
(c. 1220–92),
The Mirror of Alchemy,
published 1597

mislead the profane; often, they are simply an esoteric way of describing the techniques and the procedures of the laboratory. Their love of enigmatic expression and deliberate rejection of "normal" logic also represents the ways in which alchemy differs from pure scientific research, requiring not only the logic of experiment, but the intuitive commitment of faith.

The alchemists were not really searching for a redemptive knowledge; rather, they were convinced, as the modern scholar Paolo Lucarelli has noted, that

B elow: a 17th-century alchemist at work. "The philosophers agree concerning the first principles that you must let alone all which flies from the Fire, and which is thus consumed; all which is not of one nature, or at least of the metallic original. Consider that you must

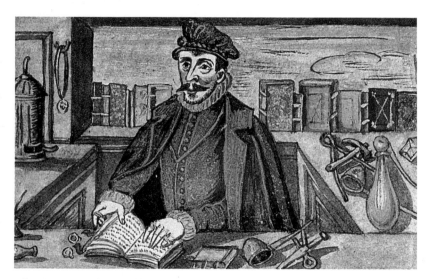

salvation was only possible through a sympathetic contact with matter—with spiritual matter, to be sought in the measure and manner required by a very ancient form of wisdom, shrouded in secrecy.

The secret language of the alchemists

The transmission of such esoteric knowledge followed a system of double encryption. First, it relied upon a panoply of complicated symbols, among which gods and heroes, real and imaginary animals, monsters and fairies revealed principles and described procedures through their relationships. Second, its mode of exposition was

have a permanent Water, which congeals in the Fire, as well by itself as joined with the perfect bodies, after having radically dissolved."
Alexandre Toussaint de Limojon, Sieur de Saint-Didier, *A Letter to the True Disciples of Hermes,* 1688, ms. Sloane 3640, British Library

labyrinthine: the steps in procedures were often described out of order so that cause and effect were obscured, or fragmented to create deliberate inconsistencies. Thus, the middle of a procedure might be described first, then its end, and finally, its first stage. Sometimes working procedures were broken up into several parts and then scattered throughout several chapters, or even volumes. This is one reason why the order and sequence of operations in the *opus magnum,* such as the Nigredo, Albedo, Citrinitas, and Rubedo stages of transformation, are debated.

These are not the only difficulties. The *modus operandi* of the Great Work itself varies from one author to another; and even the best works contain lacunae and are adorned with false recipes, designed to increase confusion. Further, the language of alchemy rarely gives us a single meaning for any term. This is because what it designates is never seen from a single point of view, but as a function of the role, by turns element, principle, subject, or object, it may play in the Work. At the beginning of its history in the West, alchemy drew on Hermetic traditions that used a disguised linguistic system, which is called the phonetic Cabala.

The Hermetic Cabala

The Hermetic Cabala shares a characteristically medieval taste for symbolic and allegorical language, as well as some methodologies, with the body of Jewish mystical writings known as the Cabala, but it is in other ways profoundly different.

"The most basic tenet of alchemy is that there are two primary ways of knowing reality…The first way of knowing is rational, deductive, argumentative, intellectual thinking that is the hallmark of science…The alchemists called this solar consciousness, and assigned it many code words, such as the King, the Sun, Sulphur, Spirit, the Father, and ultimately the One Mind of the universe…The alchemists called the other way of knowing lunar consciousness. This intelligence of the heart is a non-linear, image-driven, intuitive way of thinking that is an accepted tool of the arts and religion. Among its many symbols are the Queen, the Moon, the metal Mercury, the Soul, the Holy Ghost, and ultimately the One Thing of the universe."
Dennis William Hauck, 1998

Le Jeune ☿ doit dominer par son poids de 10♀
de plus que les 2 autres ensemble.

Et peu à peu prendre comme beurre ou fromage en pilant et agittant ça et la quand et quand
lavant auec l'eau claire vulgale tant que l'eau en vir claire, et que la masse
semble claire et blanche, (ainsy sera r sub lune sire) alors en faitte conjonction
d'iceluy, auec la saturnie regalle solaire : quand est donc a maintenant ainsy que
beurre, prenda la masse que séchera doucement auec toîte ou drap fin, moult
Lugin. Voila nôtre Plomb MA et nôtre masse du ☉ et ☾ non vulgale aince

L'hitoro speaux, a donc mettre d'iceluy dans vne bonne rétorte de terre a /rouse, moult
mieux D'acier puis en fourner et donne feu en alant petit a petit a petit. ajence vr
réceptoire a la rétorte, comme en mettieu deux heure, et après dégon son feu tant
que le ☿ mettant le réceptoire dessus dit, et en d'iceluy ☿ l'eau du Rosier floursant (a
№. 21. explication de la 3. figure ouest dépeint la représentation dun fleue
agreable soit le sommet dune montagne

a) c.a.d. L'√ don sozy le Rosier qui porte de fleurs blanches et rouges : c.a.d. lunaires et solaires

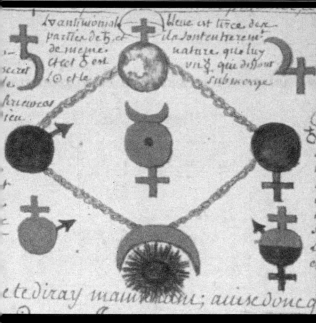

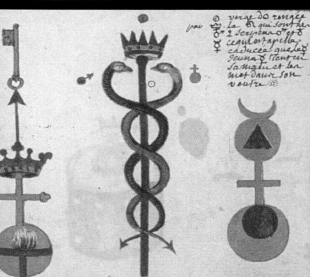

An 18th-century suite of illustrations to the *Alchimie* of Nicolas Flamel mixes esoteric symbols and the practical tools used for operations. Far left: at top are mortars and pestle; supreme importance is given to the instruments of pulverization. At center, among other emblems, are the earth, whose sign is a globe surmounted by a cross, together with the sun and moon and the furnace and alembic used in the precipitation of salts. Near left, above: the series of metallic and cosmic correspondences that participate in the preparation of philosophical mercury; note the recurrent symbol of the earth. Near left, below: earth symbols flanking the caduceus of Hermes, whose two entwined serpents represent the solar and lunar forces. The union of these polarities is the conjunction of alchemical principles that will produce the Philosopher's Stone, the "matter which is one and which is everything," writes Antoine-Joseph Pernety (1716–98), "because it is the principle at the root of all mixtures. It is in everything and like everything because it is capable of taking all forms."

selont lengin de louvrier, mais ne po

re baille.

$$V^3 = 12.$$
$$V = 9.$$

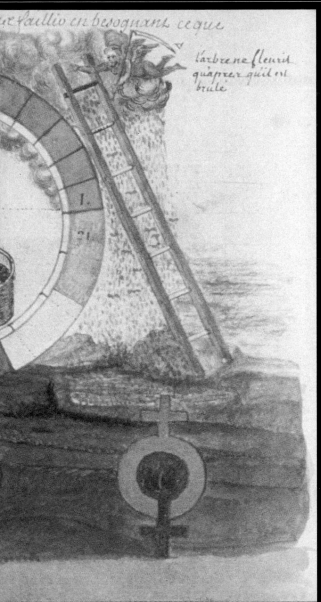

il faillit en besognant ce que

l'arbre ne fleurit
quiapres quil est
brulé

The ladder of wisdom unites earth and heaven; lodestone within the sacred flask holds the universal spirit. Flamel writes: "This is why Dardarius says in the [12th century] *Turba philosophorum*: 'Mercury is the permanent water without which nothing takes place, because it has the virtue of spiritual Blood which, when it is joined with the Body, changes into Spirit by this mixture; and reduced to one, they change each other, since the Body incorporates the Spirit and the Spirit changes the Body into Spirit, holds it and colors it with Blood, since everything that has Spirit also has Blood and Blood is a spiritual humor which strengthens Nature.' "

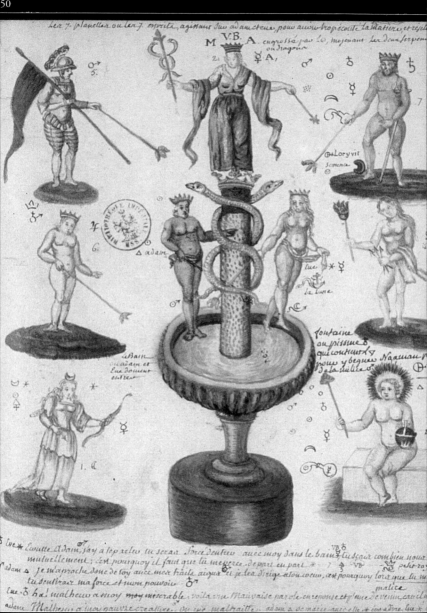

Far left: allegorical figures represent the metals and planets paying homage, Flamel explains, to the "occult stone, sunk to the very bottom of a fountain, which is vile, abject, and stripped of value; and it is covered with mud and excrement; and in it, as in one alone, is reflected each name. Because, as the sage Morienus says, this stone is not an animate stone, with the power of procreation and generation. This stone is soft, taking its beginning, its origin, and its race from Saturn or from Mars, from the Sun and from Venus." Near left, above: an allegorical composite figure represents earth, air, fire, and water. Below: the purity of the Philosopher's Stone is represented allegorically as a virgin. The alchemist Eugène Canseliet explains the symbolism of this image: "As a young princess abandons her rich clothes on her wedding night to show herself to her husband in her virginal and sumptuous nudity, so too the stone abandons one by one its admirable colors and keeps only the transparent crimson of its exalted body, in comparison with which most sages consider that red itself is false." The color red is related to the alchemical operation known as Rubedo, a stage in the stone's transmutation from *prima materia* to Philosopher's Stone.

et 2 @ viuante que ♀ enfe

Enfin quand le ☿ est animé
dans les proportions que le
chaque partie d○ oy vous au
de ♂ animé. vous new me
votre oeuf que 4 ♂ qu
ou 1. ont. qui sera fai
proportion dune partie
est 5 ♂ ½ 2 ♂ de ♃ et
de ♀

he° 50°
80 350

80.
350
50 . 3 emaine
2
410.

Philalethe dit quaprès que le M A est fait, on est
le maitre de ne prendre quun grос pour mettre
dans son oeuf proportionne

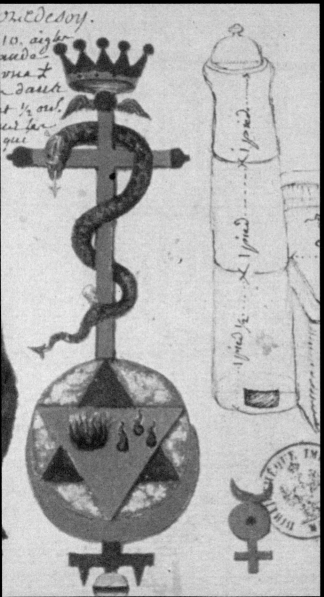

Alchemical operations include those done according to the wet way and those of the dry way. We see here the operative diagram of the dry way, divided into two parts. At left are two specialized furnaces: the tall one in the form of a tower is used for calcination, conjunction, and separation. The other is called the sand bath, and is used for those processes requiring a gentle and constant heat, such as the long process of assation. At center is a famous emblem called the "crucified snake of Flamel," a synoptic image that unites the symbols of sulfur and mercury, the opposing metals of fire (dryness) and fusibility (liquid) that together create gold (the Philosopher's Stone).

Its use may be traced to at least the 3d century AD, when it became the linguistic basis for the principal works of alchemy, as it still is today. The great early 20th-century alchemist known as Fulcanelli (probably Jean-Julien Champagne, 1877–1932) traces the word to a Greek term meaning "one who speaks an incomprehensible language"—and, in fact, the reference to an ancient Greek etymology is typical

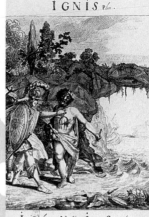

IGNIS *Plm.*

In Gehenna Nostra Ignis Scientia

CHAOS

Caliditas Humiditas Alger Occulta Siccitas

of the Cabala. He comments, "The Latin *caballus...* [means] a packhorse; indeed our Cabala truly bears a considerable weight, the burden of ancient knowledge and of medieval chivalry..., a heavy burden of esoteric truths transmitted by it throughout the ages. This was the secret language of the cabaliers, cavaliers, or chevaliers. Initiates and intellectuals all knew it. Both, in order to gain the fullness of knowledge, metaphorically sat astride the horse, the spiritual vehicle whose archetypal image is the winged Pegasus of the Greek poets."

Word magic, one of the favorite literary devices of the alchemists, unfolds powerfully in acronyms, terms whose meanings magically develop in layers, thus leading to knowledge.

The *raison d'être* for the Hermetic Cabala was to attain the most absolute esotericism in alchemistic treatises. To this end, a hybrid linguistic system was developed that used assonances, puns, and anagrams to turn words from their common usage, and often buried second and third meanings in them. Thus, the true alchemical significance of a word or phrase may sometimes be extracted by splitting and recombining it. The conjunction of all of these effects turns any alchemistic text into a real brain-teaser. Nonetheless, the most important rule of the Cabala is...to have no rules!

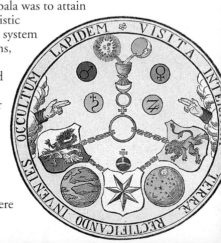

Only those who possessed the code were

TERRA

Tanan E. Cancer terum Rogni brevide m Rotando Aurestas Sum

able to understand the intended distinctions within these texts, and to draw from them the teachings about procedures in the laboratory. How could the uninitiated reader suspect, for example, that with the title of a work called *Amilec, ou la graine d'hommes* (*Amilec, or the Seed of Men*) there lay hidden an alchemistic work whose real anagrammatic title is *Alcmie, ou la crème d'Aum* (Alcmie, or the Cream of Aum), or that the work was a treatise instructing in the extraction of the spirit contained in primitive matter?

Fulcanelli reminds readers that the ancients called the Hermetic Cabala "the language of birds." Is it not tempting to think that, perhaps in support of their alchemistic works, the Franciscans, so well versed in this sacred art, spread the legend of Saint Francis, who also understood and spoke the language of birds?

Using this acrostic language, practitioners of alchemy often hid their true identities behind pseudonyms. They did so not only because alchemy in some periods was banned by religious and secular authorities afraid of witchcraft, but also because the adepts of true wisdom must be as secret as the wisdom itself. Only a Cabalistic interpretation allows us to identify the mysterious philosophers who signed themselves Eirenaeus Philalethes (George Starkey, 1628–65), meaning "peaceful lover of truth," or Basil Valentine (15th or 16th century), who claimed to be as powerful as a king

B elow: the great Paracelsus holds in his hands the pommel of a sword marked "Azoth," the name for the universal spirit, the philosopher's mercury, the greatest mystery of alchemy. The name contains the letters a and z, cabalistically the first and last things of creation.

(*basileus,* in Greek), thanks to the prodigious virtues of the
Philosopher's Stone, or Marcellus Palingenius Stellatus
(Pietro Angelo Manzolli, c. 1500–1543), who in his
Hermetic name combined Mars (iron), Helios (the sun),
and palingenesis (genetic recapitulation), to hint that he
could command the regen-
eration of the sun-gold,
by means of fire.

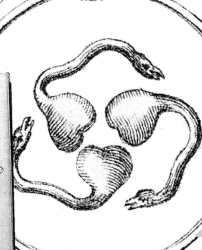

These masters
asserted that all the
instructions necessary
to succeed in the Work
were hidden in their
writings. A common exhortation was *Ora, lege, relege,
labora, et invenis,* that is, "Pray, read, reread, work, and
you shall find." The alchemists held that a pious soul,
when joined with an iron will in study and practice, could
in the end find the keys to the gates of truth.

Similarly, alchemical illustrations to the treatises are
often acrostics, rebuses, or even more elaborate visual
puzzles. (One treatise, the *Mutus liber,* is composed
solely of such images.) For example, a picture from
Basil Valentine's *The Twelve Keys to Philosophy*
(see page 58) is interpreted in this way for the
uninitiated, in a treatise titled *The
Hermetical Triumph* (1723, from a 1689
French text): "[Others] consider in

The 18th-century alchemist Baron Wilhelm von Schroeder said: "When the philosophers speak straightforwardly, I distrust their words, when they explain themselves through riddles, I think." There were many reasons, moral, cultural, and religious, for this obscurity of language. Perhaps the most important lay in the evocative power of this type of expression, as if the effort necessary to elucidate could bring about illumination. Salomon Trismosin offers an example of allegorical writing, companion to the mysterious images: "Among these contradictions and apparent lies we find the truth, as among these thorns we pluck the mysterious rose. We cannot enter into the rich garden of the Hesperides to see the golden tree and pick the precious fruits without killing the dragon that always watches over it and defends the entry. We cannot go in search of this golden fleece without facing the storms and reefs of this unknown sea, running between the rocks that clash together and shatter, and without killing the dreadful monsters which guard it."

general a mutual Correspondence betwixt the Heavens and the Earth, by Means of the Sun and Moon, who are like the secret Ties of this Philosophical Union. They will see in the Practice of the Work, who parabolical Rivulets, who mixing

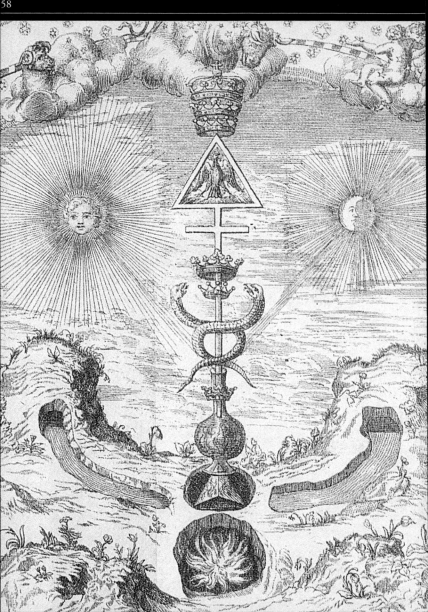

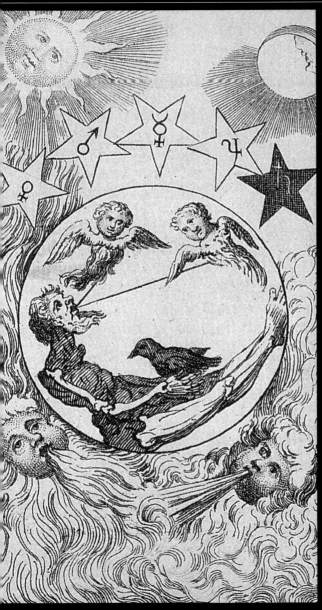

The illustrations in the treatises bear complex meanings, revealed to whoever is willing to meditate upon them. Far left: this intricate emblem from Basil Valentine's *Twelve Keys to Philosophy,* with a caduceus surmounted by three crowns, flanked by sun, moon, and cavelike openings in the earth may be understood on several levels. "Those that are initiated in the Philosophick Mysteries, will easily and presently comprehend the Sense which is hid under this Figure," writes the anonymous author of *The Hermetical Triumph: or, The Victorious Philosophical Stone,* 1723. Near left: a striking symbolic illustration of the first operation of the Work, also from Valentine's *Twelve Keys.* He writes that "in the realm of Saturn, the great old man of stone" speaks: "I am old, weak and sick…Fire torments me too much, and Death rends my flesh and breaks my bones…My Soul and my Spirit have abandoned me. Cruel poison, I am like the Black Crow…In my Body is found Salt, Sulfur, and Mercury. Let them be sublimated, distilled, separated, purified, coagulated, fixed, heated, and washed as they should be, so that they will be completely free of their waste and their filth."

themselves secretly together, give Birth to the mysterious Triangular Stone, which is the Foundation of the Art. They will see a secret and natural Fire, of which the Spirit penetrating the Stone, sublimes it in Vapours, who condense themselves in the Vessel. They will see what Efficacy the sublimed Stone receives of the Sun and Moon, who are its Father and Mother, of whom it inherits presently its first Crown of Perfection. They will see in the Continuation of the Practice that the Art gives to this Divine Liquor a double Crown of Perfection, by the Conversion of Elements, and by the Extraction and the Depuration of the Principles, by which it becomes to be that mysterious [rod] of *Mercury,* which operates such surprising Metamorphosings. They will see that this same *Mercury,* as a *Phoenix,* who takes a new Birth in the Fire, arrives by the Magistery to the last Perfection of the fixed Sulphur of the Philosophers, which gives it a foreign Power over the three Reigns of Nature; of which the three-fold Crown (upon which is set for this Purpose the Hieroglyphic Figure of the World) is the most material Character."

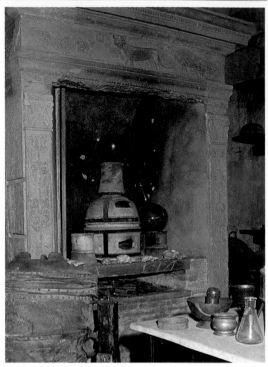

A bove: a reconstruction of a 16th-century alchemical laboratory. The furnace, in which all operations take place, is the heart of the laboratory, the theater of the action of nature's fire. The Cosmopolite wrote, c. 1600: "Those who examine Nature must be like Nature itself, truthful, simple, patient, constant, etc., and, of primordial importance, pious, God-fearing, charitable to their neighbors."

The initiation into alchemy

Undeniably, it was an advantage to have instruction in the true road from a master. The most famous alchemists, such as the Swiss Paracelsus (Theophrastus Bombast, c. 1493–1541), the German Heinrich Cornelius Agrippa

von Nettesheim (1486–1535), and the Englishman Robert Fludd (1574–1637) are unique, although they all follow the same immutable discipline. The monk Johannes de Rupecissa (author of *The Book of Quintessence or the Fifth Being*, c. 1354) in no way resembles Alexandre Toussaint de Limojon, Sieur de Saint-Didier (author of *A Letter to the True Disciples of Hermes, wherein are Six Cardinal Keys of the Secret Philosophy*, 1688); Nicolas Flamel (1330–1418) was a simple French bookseller and scribe; Jacques Coeur (c. 1395–1456) a banker at the court of King Charles VII of France. Alchemy in its heyday imposed no particular career on its disciples. Yet all were initiates, brothers beyond the distances of time and place.

What was an alchemical initiation? It is difficult to say, but it probably corresponded little to the descriptions usually associated with the word. Reading the testimony of the principal adepts, we find no mention of the complicated rituals that characterized many other secretive communities. The neophyte was enjoined to become as simple and pure as the nature he or she wished to follow, and was then required to swear to keep the secrets about to

"We are of course quite ignorant of the exact nature of the crucial experience which for the alchemist was equivalent to obtaining the Philosopher's Stone or the Elixir…alchemical literature makes only cryptic…allusions to the *mysterium magnum*. But if we are right in insisting on the interdependent relationships between mineralogical symbolism, metallurgical rites, the magic of fire and the beliefs in the artificial transmutation of metals into gold by operations which replace those of Nature and time; …if, in short, the Alexandrian alchemists did, as seems probable, project on to mineral substances the initiatory spectacles of the Mysteries—it becomes possible to penetrate into the nature of the alchemical experience. "
Mircea Eliade,
The Forge and the Crucible, 1956

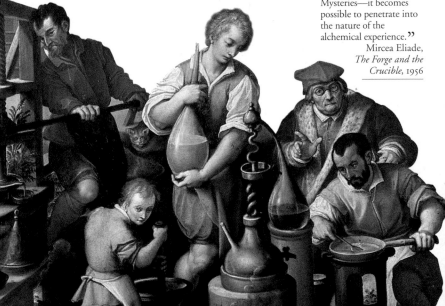

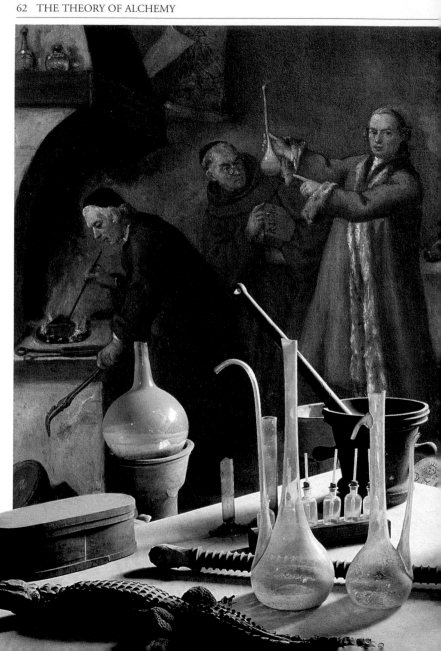

be revealed. Other aspects of the induction varied, and compared with these two points were unimportant.

Reborn as a philosopher

It is only through the imagination that we may find the key to this mystery. Let us therefore enter a laboratory of the 16th century, perhaps on a peaceful spring night, and examine the scene revealed to us: the room has a furnace, called the Athanor (from the Greek *athanatos,* immortal: the furnace of the immortal flame), with tongs and bellows; it is furnished simply, with a workbench containing a still, mortars, and pestles; a few books rest on a simple bookshelf. Perhaps there are jars of poisons—vitriol and nitric acid, sulphur and mercury—as well as retorts and other vessels.

We see a noble, venerable master and a devoted student, eager for knowledge. Silence falls in the room; the moment is solemn; the fire in the furnace burns, fed by the bellows. The oath of the Brothers of Hermes has already been spoken, and the pupil now awaits precise instructions to proceed. The materials have been explained; the times and procedures set forth; from this moment on, no initiate will ever be the same. What he or she was before means nothing, since name, age, and personality are about to be forever changed. In the allegorical language of alchemy, the poisonous dragon is about to be destroyed by fire. The fledgling waits, knowing that his or her most intimate substance has been joined in the crucible with the matter that will soon be delivered to the martyrdom of fire; the apprentice will die, to be reborn as a philosopher.

This is the true point of departure, the beginning of the dangerous journey. There are no promises except for fatigue and a path strewn with detours.

Nonetheless, the reward may be enormous; a prize unknown to the commonality, but priceless to the philosopher: the epiphany of the spirit.

A manuscript in the Biblioteca Marciana in Venice contains a fascinating formula for the oath taken by acolytes of alchemy. According to legend, it was dictated by Ammael to the goddess Isis, wife of Osiris: "I swear by heaven, by earth, by light, by shadows; I swear by fire, by air, by water, and by earth; I swear by the height of the heavens, by the depth of the sea, and by the abyss of Tartarus; I swear by Mercury and by Anubis, by the baying of the dragon Chercouroboros, and the three-headed dog Cerberus, guardian of Hell; I swear by the ferryman Charon; I swear by the three Fates, by the Furies, and by the bludgeon never to reveal these words to anyone who is not my noble and charming son. And now go, seek out the farmer and ask him which is the seed and which the harvest. From him you will learn that whoever sows wheat will get wheat, whoever sows barley will get barley. This will lead you to the idea of creation and of generation; remember that man is born of man, the lion is born of the lion, that the dog is born of the dog. This is how gold produces gold, and here is the mystery itself!"
Ms. CCXCIX, Biblioteca Marciana, Venice

The alchemists sought an extraordinary thing: spiritual illumination rendered in material form. They devised secret and dangerous procedures to obtain it. But what was this stuff the ancient masters called the Philosopher's Stone, or the Elixir? How was it made?

CHAPTER 3
THE PRACTICE OF ALCHEMY

Hermetic knowledge is distinguished by its functional character. "It does not formulate, but creates; it concerns a Work, not a philosophical dialectic," wrote René-Adolphe Schwaller de Lubicz, known as Aor (1887–1961). Left: detail of an illustration to a book on Nicolas Flamel, showing the implements of the alchemist. Right: the angel who holds the keys to the mysteries indicates that this knowledge is forbidden to whoever cannot possess them.

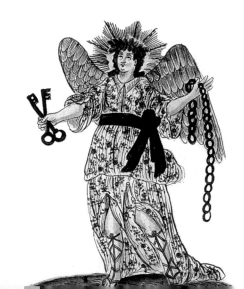

According to mainstream culture, no alchemist has ever succeeded in turning base metal into gold. But in the alchemical literature there are numerous descriptions of the supreme substance—many of them remarkably similar, despite widely differing sources. And these are supported by the texts of learned spectators, whose accounts contain credible and enthusiastic testimonials.

As we have seen, the Philosopher's Stone was understood not as mere gold itself, but as a substance capable of transforming the very nature of matter, and of sustaining life. The aim of the *opus magnum* was to create, or synthesize, this mysterious compound. In practical terms, this meant creating gold from other metals, through a series of operations in which they were subjected to heat, acids, and various processes, and then purifying the gold to a still more refined state. In spiritual terms, it signified the perfection of the alchemist as philosopher. Materially, gold is wealth, but allegorically, gold is purity—that which does not tarnish or decay; spiritually, it is wisdom.

The Philosopher's Stone

How do the alchemists describe the Stone? The *Musaeum hermeticum* says: "We call the Philosopher's Stone the most ancient Stone of the sages, the most secret or unknown; incomprehensible in natural terms; celestial, blessed, and sacred. It is said that it is true, and more certain than certainty itself, the arcanum of all arcana—virtue and

Left: the allegorical figure of the Phoenix, the mythical bird that arises from the fire which has consumed it, is a symbol of the Philosopher's Stone. The Philosopher's Stone is achieved when the old body of the material "dies" in the furnace and is reborn from its own ashes. Through fire, at the end of a long and complex series of operations, the philosopher draws a new body from the Athanor, his sacred oven. Below: the Philosopher's Stone represented schematically.

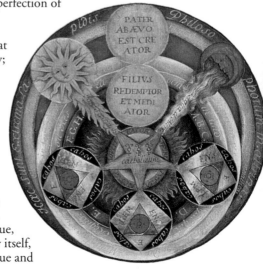

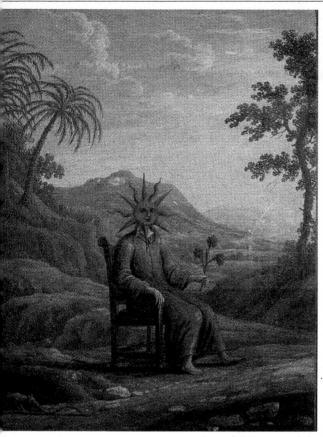

The deified alchemist, master of nature, rests in the serene harmony of creation, holding the triple rose of Hermetic science. This figure's smiling face, depicted as a sun, is both symbol of the Light and source of illumination. In the distance is the sunrise, dawn of a new existence: the alchemist, having arrived at the end of arduous efforts, "is now," as Eugène Canseliet writes, "no longer unaware that the Philosopher's Stone is the goal of the Great Work, that it is not only the agent of the transmutation of base metals into silver or gold, but the universal Medicine. It grants the adept (*adeptus,* one who has attained or obtained) eternal life, with omniscience and worldly riches, in the most absolute sense of these three words and their attributes." In him, the words of Marcantonio Crassellame (*Lux obnubilata,* 1666) still resonate: "Be careful to understand the Philosopher's Stone; at the same time, you will have attained the foundation of your health, a wealth of riches, the notion of true natural wisdom, and a clear understanding of nature."

power of the divinity, hidden from the ignorant, end and goal of all things under the sky, definitive and marvelous conclusion of the operative work of all the sages. It is the perfect essence of all the elements, the indestructible body that no element may damage or harm, the quintessence; it is the double and living mercury which has within it the divine spirit—the treatment of all the weak and imperfect metals—the sempiternal light—the panacea of all ills—the glorious Phoenix—the most precious of all treasures—the greatest possession in all of nature."

In esoteric symbolism the Philosopher's Stone is represented by the sign of the sun. This is characterized by its color, which is a changeable red. In the words of Basil Valentine, "Its color is a scarlet red shading to crimson, or ruby color shading to the color of garnet; as for its weight, it weighs much more than one would say from its color." Such details suggest the extraordinary nature of the Stone, which bore little resemblance to any other known thing. It seems to have had the appearance of a crystal and the mass of a metal. The Renaissance author known as the Cosmopolite said this of it: "If we find our subject at its highest degree of perfection, made and composed by nature, it should be meltable like wax or butter (147°f, or 64°c) and its red color, its diaphanous and limpid character should be visible upon its exterior." "The Stone," Fulcanelli affirmed, "unites powerful chemical properties: the power of penetration; absolute fixity; incorruptibility, which makes it uncalcinable; an extreme resistance to fire; and, finally, a perfect indifference to chemical agents."

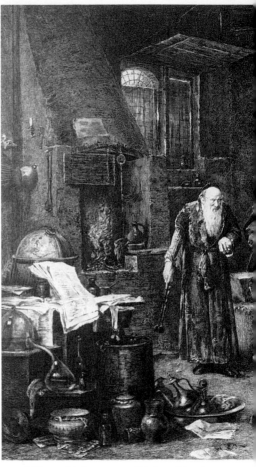

Base metals were transformed in a series of stages, called operations, the last of which produced the Stone. The order and nature of these was not fixed, but in general the material was transformed through various chemical processes and the resulting substance or substances placed in a vessel, hermetically sealed, and set

Often, alchemists worked under the patronage of the powerful, who hoped to obtain wealth from them, and sometimes forced them to give public demonstrations of their experiments. This is one of the reasons practitioners were enjoined to secrecy.

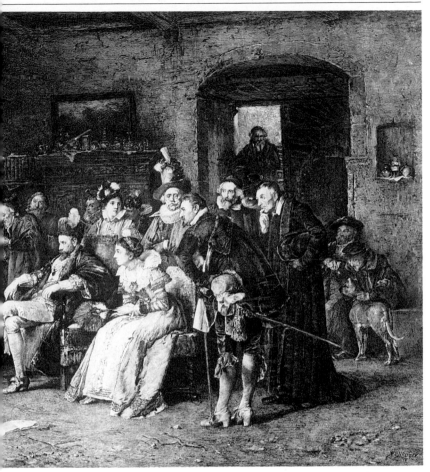

within the special furnace known as the Athanor, which maintained steady heat for a long time. Each operation led to a change, marked by an alteration in color, from black to white to yellow, and finally red. (Interim colors such as green or the transient hues symbolized by the peacock's tail were also sometimes present.) Each of these stages had its own importance, its own allegorical and literal meanings, and its own Latinate name, based on the color it achieved: the Nigredo (black), Albedo

Above: Michael Sendivogius (1566–1636) effects transmutation at Prague, in the presence of Emperor Rudolph II. This prince, a singular figure in the Renaissance, was an ardent defender and student of the Hermetic arts.

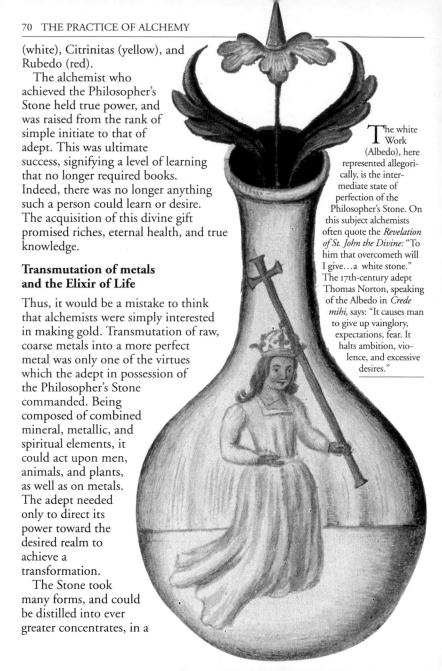

(white), Citrinitas (yellow), and Rubedo (red).

The alchemist who achieved the Philosopher's Stone held true power, and was raised from the rank of simple initiate to that of adept. This was ultimate success, signifying a level of learning that no longer required books. Indeed, there was no longer anything such a person could learn or desire. The acquisition of this divine gift promised riches, eternal health, and true knowledge.

Transmutation of metals and the Elixir of Life

Thus, it would be a mistake to think that alchemists were simply interested in making gold. Transmutation of raw, coarse metals into a more perfect metal was only one of the virtues which the adept in possession of the Philosopher's Stone commanded. Being composed of combined mineral, metallic, and spiritual elements, it could act upon men, animals, and plants, as well as on metals. The adept needed only to direct its power toward the desired realm to achieve a transformation.

The Stone took many forms, and could be distilled into ever greater concentrates, in a

The white Work (Albedo), here represented allegorically, is the intermediate state of perfection of the Philosopher's Stone. On this subject alchemists often quote the *Revelation of St. John the Divine:* "To him that overcometh will I give...a white stone." The 17th-century adept Thomas Norton, speaking of the Albedo in *Crede mihi,* says: "It causes man to give up vainglory, expectations, fear. It halts ambition, violence, and excessive desires."

Alchemistic texts that speak of the magisterium, the last stage of transmutation of the Philosopher's Stone, report that in the Athanor the matter being heated undergoes remarkable variations in color, and that this signals the success of the Work. Color is the mirror, or sign, of the transmutation of matter by the spiritual agent. The material's first change is to black (Nigredo), then it becomes white (Albedo), then yellow (Citrinitas), and finally red (Rubedo), when it has attained its most perfect state. Left: an allegorical representation of these four stages. The Stone is the catalyst that completes the transmutation of metals; alchemists had "philosophical" medals of gold and silver struck, indicating that they were created by alchemy from lead. Below: a 17th-century medal with alchemical symbols.

process called multiplication. In a solid state, when further heated, or fermented, and fused with pure gold or silver, it became a translucent mass, red or white, depending upon which metal was used. In this form it could be pulverized, and was called the "powder of projection"; poured (or "projected") into the crucible upon a molten base metal, it had the power to alter its essence and transmute it. In a saline form, the Stone was used for a variety of tasks in the animal and plant kingdoms: it was the universal remedy for illnesses, and it maintained health and fostered growth in plants. In solution mixed with alcohol, it was *aqua vitae,* the water of life, potable gold, the Elixir of the Eastern alchemists. When chilled, the Stone did not return to a crystalline state, but remained fluid, luminescent in itself: a source of light, and also of illumination to the alchemist. The modern alchemist Eugène Canseliet said that it gave the adept the triple gift that the Magi had brought to the Christ Child: gold (wealth), frankincense (symbol of divine wisdom), and

myrrh (a substance that, according to ancient Egyptian tradition, granted immortality).

But these gifts were all achieved in the last phase of the Work. To arrive at that point, a long experimental journey was required, with recourse to many secret procedures, difficult to carry out. The Great Work, the *opus magnum,* was the name given to this immense effort.

The Great Work

This was much more than a mere collection of procedures. The first step was to read the works of past masters, to search for lost, obscure, and precious treatises, acquire them, and read them attentively, with the special interpretive perceptiveness alchemy demanded. The Great Work meant many nights without sleep, seeking revelation.

And the Great Work meant the act of examining the world with new eyes, the "exultation in looking about one," as Elemire Zolla wrote, "lifting up a fragrant piece of soil, picking a fruit, contemplating the iridescence of waterfalls or jewels, the splendor of human incarnation, of a flaming flow of metal." In this way the adept would begin to understand the "presence that animates, shapes, and continues to shape matter, and sometimes grasps and hardens it in its fist; sometimes breaks it into pieces and makes it flow like a liquid

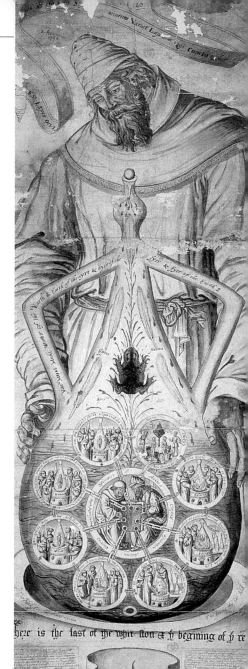

between its fingers; sometimes again caresses it and makes it shine." So would the investigator become responsive to the subtle harmony that animates the whole. "The secret of the alchemical art and all wisdom is contained in the capacity to sense with exultation this diligent hand, invisible to those who are preoccupied and unhappy."

The Great Work represented an undertaking of titanic proportions on the part of the alchemist. Through it, a simple human being was able virtually to rise to the level of a demiurge in the microcosm of the material world. To do so it was necessary to conquer matter—chaotic in itself—to purify and reanimate it, so as to infuse it with spirit. It was necessary to separate, distribute, and bring out the diverse natures of which it was formed, and then conjoin them once more into a harmonious whole. This

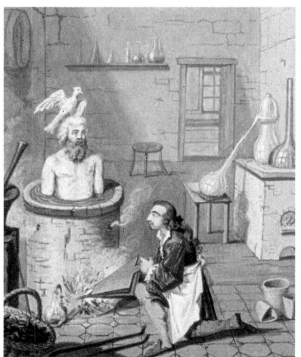

Opposite: in a 17th-century illustration, the alchemist contemplates the entire philosophical Great Work in its unitary and harmonic structure, displaying all its occult and manifest aspects. Within the Vessel, at center, the mineral selected for transmutation is allegorically represented by a black toad. In other images, a tortoise or dragon may represent the metal in its raw, chaotic state. In this condition it was called antimony, "which," wrote Artephius in the 12th century, "is in the parts of Saturn and in nature, in all its modes" (published early 17th century). Eirenaeus Philalethes says that antimony is a "chaos which is like a mineral earth, when we consider its coagulation, and nonetheless is a volatile air because inside it, in its center, is the philosopher's Heaven." And Eugène Canseliet writes that "in the beginning of creation, the artist, like God, must arrange matter within its chaos." Near left: the transmutation process is represented allegorically as an old man who must be purified many times, washed in a heated bath (the Athanor) so that he will be purged of his volatile impurities.

was the definitive spiritual act that transformed matter into the Philosopher's Stone.

We must therefore understand that the name Great Work was used as a synonym for alchemy as a whole, expressing its essence as sacred and symbolic knowledge, and the logic by which it was established as a unified philosophical system.

The characteristic mysterious phrases of alchemistic texts, with their abrupt leaps, connections, and analogies, must be seen as an attempt to synthesize the acts and

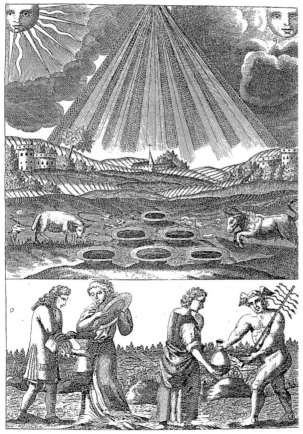

Few alchemistic treatises are as revealing as the one entitled by its anonymous author *Mutus liber,* the Mute Book, first published in 1677, with several later editions. It has no text, but its 15 plates, or emblems, contain a precise description of all the components of the alchemist's art. Left: plate 4 in the series depicts the philosophical couple gathering dew, a fluid with alchemical symbolism. This scene occurs in spring, represented by the zodiacal animals Aries (goat) and Taurus (bull). Between the sun and moon an immense fan composed of rays of fluid and innumerable particles descends to add its life-giving power to the work of terrestrial and celestial agriculture (another name for alchemy). Right: plate 15 shows the spiritualized body rising into the heavens, leaving behind the old body. The ladder of wisdom has been scaled and the angels crown the victorious adept with the laurel wreath of heroes and poets. Above them, the sun illuminates the scene with the radiance of wisdom.

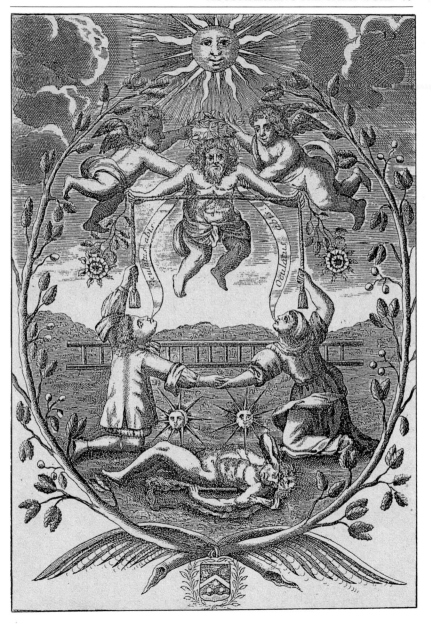

goals of the art itself. As the *Theatrum chemicum* says, "I must never ask myself anxiously if I truly possess this precious treasure. Rather, I must ask myself if I have seen how the world was created, if I understand the nature of the Egyptian obscurities, if I know what causes the rainbow, what the resurrected bodies will look like in all their glory on the Day of Judgment."

Nostrum non est opificium, sed opus naturae: ours is not a craft, but the work of nature, the masters loved to say, for the work they carried out in the laboratory repeated and reflected the great work of the divine creator. Their efforts were regulated by natural laws, profound and secret, and modified by the rhythm of the seasons, as they patiently awaited favorable conditions for their experiments. The universe, heaven and earth, stars and planets, were set in motion by the manipulations of the alchemists; entering the microcosm of the mineral world and working in sympathy with it, they chose it and claimed possession of it as the receptacle of the spirit of life.

Thus, the view of the Great Work as a mere set of chemical experiments is reductive indeed, compared with this fulfilled vision of the human microcosm in harmony with the universe, revealing the deepest mysteries of creation. That a practical process should be part of this form of knowledge— indeed intimately necessary to it—is key; to be unaware of this is to follow a false path.

The system of alchemy

It is this unity of transcendent (spiritual) and experimental (scientific) characteristics that defines alchemy; Eugène Canseliet called it an "experimental metaphysics." Alchemy presents a secret system, or theory of knowledge, a

Eugène Canseliet states, "The aspect of the Work that remains most carefully concealed by writers is that of the conditions to be observed for its literal realization...For the student must not forget this: the work is as much a matter of extended physical action as of immediate physical transformation." This is why the more "charitable," open treatises tend to specify the astral conditions favorable for carrying out procedures. Right: the alchemist works under the sign of Aries, when, in the starry nights of spring, the celestial influx is at its most powerful.

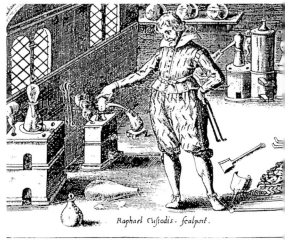

Raphael Custodis. fcalpnt.

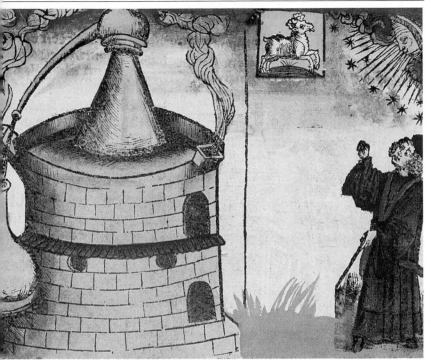

Stephan Michelspacher Ex:

Left: this laboratory scene shows the two paths of the *opus magnum*. At far left, an alchemist follows the wet way, anxiously contemplating a large, broken matrass (a long-necked flask); around him appear various tools of distillation in glass and brick. The man at right pursues the dry way: here we see the crucibles and instruments of metallurgy.

practical gnoseology in which an intricate succession of experimental procedures, responding to an infinite number of factors, may generate miracles.

Just what were the procedures the alchemists followed to achieve this extraordinary outcome? Extant manuscripts offer a range of descriptions, and some variations may be due to the relative availability of materials in different places and times. Nonetheless, a basic sequence of processes can be identified.

The stages by which a substance was gradually transformed followed one of two general methods, the "dry way" or the "wet way," also called the "moist way." The dry way was quicker; influenced by the techniques of metallurgy, it relied heavily on the principle of fusion and used the crucible constantly. Nicolas Flamel and Eirenaeus Philalethes used this method, among others, but on the whole it was not favored. The wet way was longer, and was preferred by most alchemists.

Many alchemists pursue experiments in the dry and wet ways, sometimes even at the same time. "What is to be feared [in the dry way] is…the drying-up of the waters," writes the modern alchemist Etteila in *Les Sept nuances de l'oeuvre philosophique-hermétique* (1977). "One burns and dries up, the other destroys or corrupts. In both cases Nature, instead of rendering the expected material, offers another, which is no longer the Work." Left: a detail of Jan Steen's genre scene, *The Village Alchemist,* c. 1600; below: Persian alchemists, in a painting by Mehdi, 1893.

The Theatre of Terrestrial Astronomy, a text published in 1676 and attributed to Edward Kelly, explains the basis for these two ways of working: "Geber, Morienus, and other Sages have pronounced the conversion of one element into another a very necessary process in the composition of the [Philosopher's] Stone: convert the elements, and you have what you seek. There are four elements, air, water, fire, earth, with their four qualities, hot, cold, moist, dry… Contradictory qualities are united only by means of a third. Hot and dry are not contradictory, and therefore form the element of air; cold and dry are not contradictory, and become earth; nor are cold and moist, which constitute water: but hot and cold are united only by means of a medium, viz., dry, as otherwise they would destroy each other. Hence hot and cold are united and separated by dissolving and coagulating the homogeneous quality. Moist and dry, on the other hand, are united and separated by constriction and humectation; simple generation and natural transmutation are by the operation of the elements…It is clear that all things are generated by heat and cold; and all elements must belong to the same genus, or else they could not act on each other."

The three-headed dragon symbolizes the material from which the three parts of the Work are formed, in a process that uses salt. The first achieves mercury, the second sulfur, and the third the Philosopher's Stone.

The moist way sealed the material in a globe of clear glass. This allowed the alchemist to observe and control the various phases of the Work, each identified by a change in the color of the substance. The spectacle of these chromatic alterations was called the "peacock's tail." The contemporary scholar Stanislas Klossowski de Rola states, "The

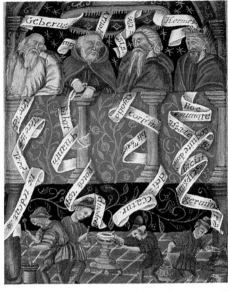

role of color is well known in the alchemical work. There are three basic colors... The Nigredo, or black, being the first sign of success, the second sign comes with Whiteness or Albedo, and the final Perfection, Tyrian Color or Rubedo, is when the final fixity is attained. There are other colors of importance such as green which symbolizes the living state, the life force." Within either of the two ways, the Great Work was further divided into three distinct phases, or

Above: four masters of the doctrine unroll phylacteries above alchemists in a laboratory. There are thousands of different descriptions of the path to the Philosopher's Stone, each cloaked in symbols and allegorical images that derive from the particular referential universe each author preferred. Nonetheless, all describe the same Work.

Works, each of which depended on the three basic substances, salt, mercury, and sulfur. Salt was used to separate and purify the other two, which were then joined together. After their reunion came the "great coction," the final stew that resulted in the Stone.

The specific procedures here varied considerably from one author to another. Albertus Magnus (1193–1280), for example, prescribed five changes: reduction of the substances to their *prima materia;* extraction of sulfur and mercury; purification of the sulfur obtained until it looks like gold and silver; preparation of this so-called white elixir; working the white elixir until it is transformed into red elixir. The whole was governed by four operations: decomposition, washing, reduction, fixation.

The texts remain ambiguous on the question of the number and duration of operations in the three phases. Some propose that there are seven or twelve, drawing an analogy with the cycles of the days and the months. Canseliet asserts that there must be nine sublimations in the Second Work, and that the "great coction" is completed in one week, at which time musical and chromatic scales will reveal to the artist whether or not he or she has succeeded.

Experimental steps of the Great Work

When it comes to examining in detail the succession of operations, the student is likely to remain perplexed, for as we have already seen, this is the most secret terrain of all of alchemy.

The texts remain vague, or disagree, upon many practical points. When and with what material does the alchemist begin the Work? What is the duration of each operation? How many times is it necessary to repeat procedures?

Let us read what some of the adepts have written. According to Rupecissa, "The matter of the stone is a thing of little worth, which may be found anywhere." Morienus affirms that "matter is unique and everywhere rich and poor possess it; it is unknown to all; it is before the eyes of everyone; it is despised by the vulgar, who sell it cheaply like mud, but the philosopher who understands it holds it as precious." These references reveal its spiritual aspect more than its literal identity.

A 15th-century manuscript called the *Most Precious Gift of God* (*Pretiosissimum donum Dei*) describes the development of the Great Work in a series of allegorical pictures with accompanying texts. Each one represents a flask surrounded by emblems roses, a king and queen, serpents, and colors that indicate the stages of the process: conjunction, putrefaction, and so on. The author, Giorgius Aurach de Argentina, writes: "I have had the science of this Art only from the Inspiration of God, who to this servant has vouchsafed to declare the true reasons to judge and discern…Forsooth if I feared not the day of Judgment I would never open anything of this science or publish it to any man…He that knoweth not the principles in himself is very far from the art of philosophy for he hath not the true book whereupon he should ground his intent. But if he do chiefly and principally know the natural causes of himself and know not the other, yet hath he the way to the way of the principles of the Art." The acolyte must have a philosophical understanding to begin with, for if not, says Eugène Canseliet, much of the Great Work, "is no different from the manipulations currently carried out in the workshops of artisans."

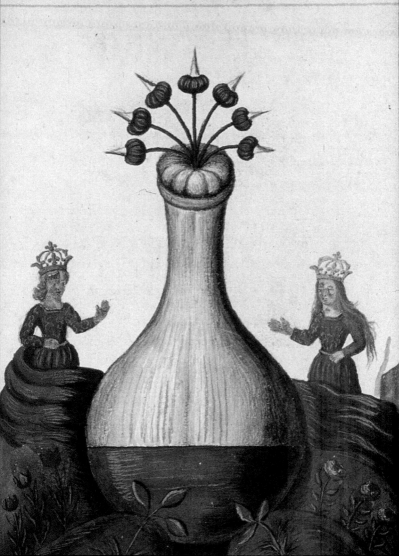

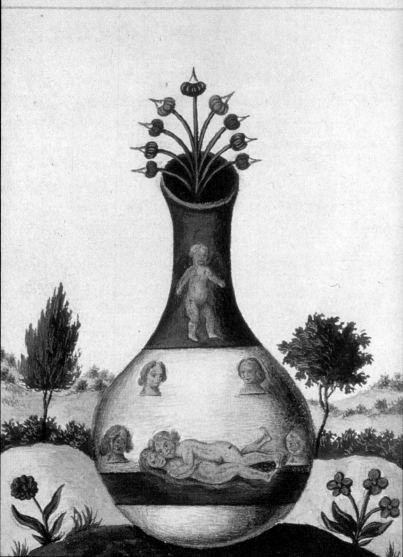

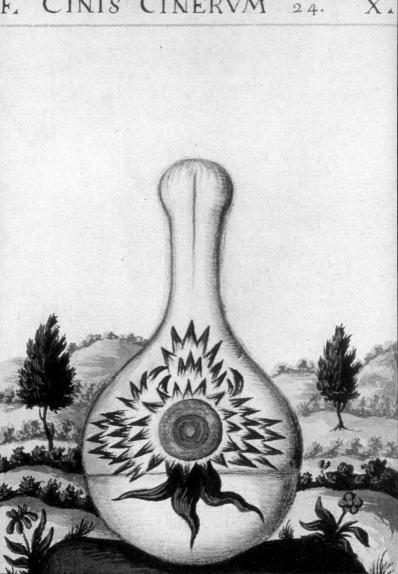

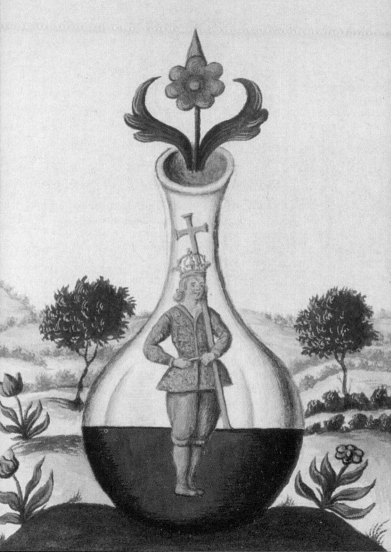

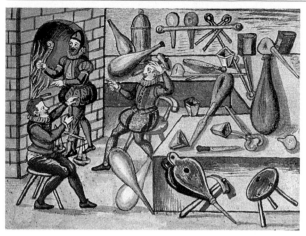

Left: under the expert direction of a master, students carry out operations. One checks the accuracy of a weight; another, standing before the burning furnace, probes the fire. All around them stand shelves of instruments: alembics and cucurbits (vessels of a still), matrasses and other flasks, bellows, tongs, a mattock, crucibles, and a book. Below: in a 1519 woodcut are types of brick oven on which are set copper cucurbits with alembics for distillation.

However, it seems almost certain that alchemists began with a mineral substance. Fulcanelli seems to confirm this: "Although entirely volatile, this primitive mercury, materialized by the desiccating action of sulfur in arsenic, takes on the look of a solid mass, black, dense, fibrous, fragile, and friable, which its lack of usefulness makes base, abject, and contemptible in the eyes of man."

The moment chosen to begin the Work was crucial; numerous references to the astrological charts indicate that the spring equinox was considered the proper time. Indeed, in a project that aspires to follow nature, what moment could be more propitious than that which since the beginning of time has marked the rebirth of the earth? By analogy, the Work was concluded in summer, when fruit comes to ripeness.

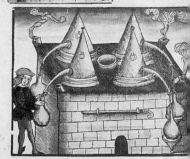

The alchemist in the laboratory

The true alchemist is quite unlike the nonsensical images of necromancers found

in popular literature. "Where are the bones and skulls, the spider webs, the dust?" the modern student exclaims. "Where are the homunculi? Where is the chaotic jumble of retorts and alembics? Where are the hidden pentangles, the formulas for exorcism, the shelves filled with strange stuffed animals, representatives of mysterious powers?" This mythical apparatus remains the legacy of fiction and superstition.

But another

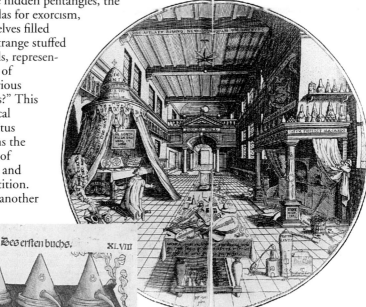

pernicious legend continues to encumber the contemporary alchemist. It holds that the true alchemical workshop differs from that of the common glassblower only by its organization. This is nonsense. The latter is a simple workplace; the

Above: at left in this complex image is an enclosed altar, or oratory, a place of spiritual contemplation. At right is a laboratory; the alchemist works in this twofold workshop. At center is a table of musical instruments, scales, and tools, representing the harmony and balance necessary to the Great Work. Other alchemical objects and inscriptions adorn the scene.

The alchemist as artist's model

A speculative tension has always animated alchemistic research. In this scene we can almost breathe the dramatic atmosphere, filled with mysterious signification. The disordered clutter of tools and accessories, the preoccupied, downcast gaze of the alchemist, plunged in study of rare manuscripts, give a precise picture of the emotional combat that is the lot of the hermetic philosopher. This solitary form of research has always demanded great physical and mental efforts: an interior endeavor in service of an esoteric quest that all too often ends in disillusionment and defeat. Nonetheless, this laborious experimentation was fueled by faith and tenacity, sustained by constancy and persever-ance, aided by sage texts, and fed with the hope of achieving what Arthur Rimbaud, in the poem "Vowels," called the "peace of the wrinkles which alchemy prints on heavy studious brows."

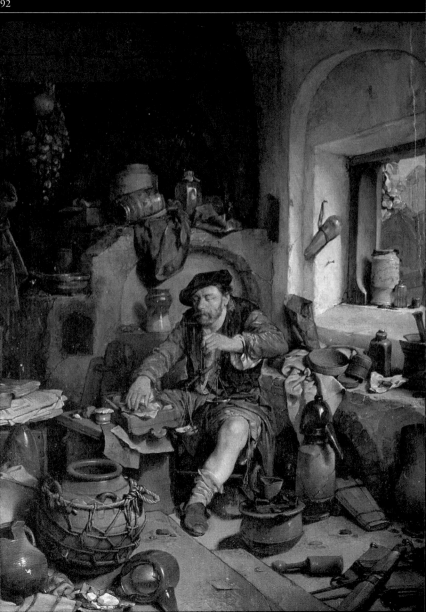

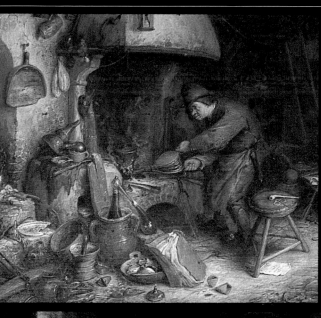

Painters have often taken alchemy and alchemists for subjects, attracted by the dark drama of their imagined scenes, and by the image of the solitary, creative seeker after enlightenment: one sort of artist speaking to another.

former, the repository of a spiritual quest whose sacred nature cannot be fully contained within four walls.

For the alchemist does not seek faith, but is filled with it, worshiping the divine by worshiping created matter—by operating upon it. Work in the alchemical laboratory is a true form of prayer, in contact with the divinity. This conviction guides the philosopher's steps, just as his or her vocation is to spiritualize matter by establishing a relationship of identity with it in concrete terms. Alchemy is cloaked in mystery, but only because it is constrained to be so. Its rule is simplicity, and the effort that purifies the spirit of the practitioner is visible also in the arrangement of the workshop. The practice of the art is dictated by necessity. The character whom we see henceforth should not seem exotic to us, but should excite our admiration.

Let us now enter the modern alchemical workshop. Without obfuscation, let us observe the simple tools of the art. The equipment is much the same as that which would have been found in the 16th-century studio, or indeed in ancient Alexandria: the Athanor, with thick walls to melt and calcine and burners with adjustable levels of heat; the usual tongs and bellows; crucibles of earthenware and vessels of glass; and long-handled spoons. There are a mortar and pestle, ceramic pots and pans, some contrivances for distillation and filtration, jars to preserve substances. There is a well-stocked library.

The space is well-ventilated and immaculate, set in a propitious location, chosen for its ability to attract the vital fluids of nature, its spiritual emanations, and the cosmic rays of the sun and moon. This is the *sancta sanctorum* of the alchemist.

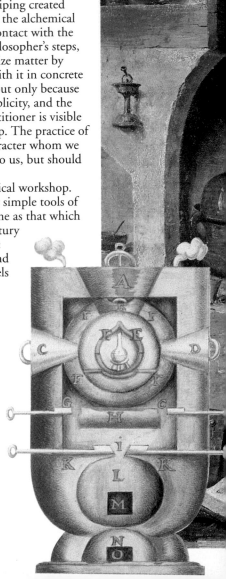

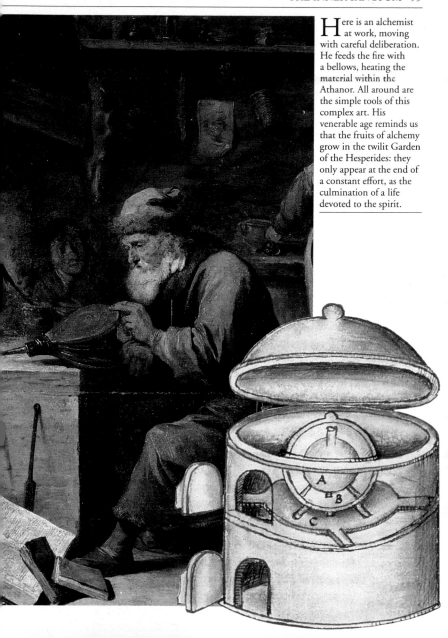

Here is an alchemist at work, moving with careful deliberation. He feeds the fire with a bellows, heating the material within the Athanor. All around are the simple tools of this complex art. His venerable age reminds us that the fruits of alchemy grow in the twilit Garden of the Hesperides: they only appear at the end of a constant effort, as the culmination of a life devoted to the spirit.

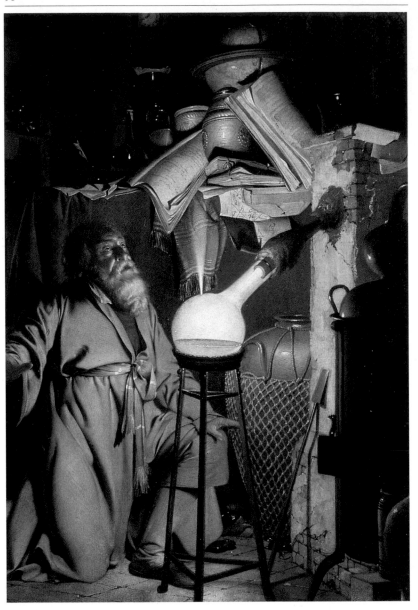

DOCUMENTS

Ora, lege, relege, labora, et invenis.
Pray, read, reread, work, and you shall find.

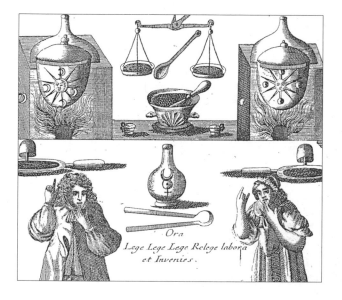

The earliest sources

The ideas and practices out of which alchemy arises began to appear in texts around the first millennium BC, though their earliest roots probably date to the Iron Age. Alchemy was born from the sacred arts and practical techniques related to metallurgy of ancient Egypt, Phoenicia, Greece, and the Near East.

Previous page: engraved plate in the *Mutus liber*, 1702; above: Two "chemists" at work in Mesopotamia, from a 3d millennium BC drawing.

The Emerald Tablet of Hermes

This text was long thought to be the oldest of all alchemical documents, and appears in numerous ancient and medieval translations from the Arabic, Greek, and Latin. In 1614, it was identified as having been written in the Christian era, but nevertheless retained its great influence. The English physicist and mathematician Isaac Newton (1642–1727), who was interested in alchemy, recorded this version in the 1690s.

Tis true without lying, certain & most true.

That wch is below is like that wch is above & that wch is above is like yt wch is below to do ye miracles of one only thing.

And as all things have been & arose from one by ye mediation of one: so all things have their birth from this one thing by adaptation.

The Sun is its father, the moon its mother, the wind hath carried it in its belly, the earth is its nourse. The father of all perfection in ye whole world is here. Its force or power is entire if it be converted into earth.

Separate thou ye earth from ye fire, ye subtile from the gross sweetly wth great indoustry. It ascends from ye earth to ye heaven & again it descends to ye earth & receives ye force of things superior & inferior.

By this means you shall have ye glory of ye whole world & thereby all obscurity shall fly from you.

Its force is above all force, ffor it vanquishes every subtile thing & penetrates every solid thing.

So was ye world created.

From this are & do come admirable adaptations whereof ye means (Or process) is here in this.

Hence I am called Hermes Trismegist, having the three parts of ye philosophy of ye whole world.

That wch I have said of ye operation of ye Sun is accomplished & ended.

Isaac Newton,
Keynes ms. 28, ff. 6r–7r,
King's College, Cambridge, c. 1690

Mary the Prophetess

A 17th-century manuscript in the British Library records a dialogue between Mary the Prophetess, a figure said to be from ancient Judaic tradition, and a disciple named Aros. Versions of this manuscript appeared in various alchemical texts in the 16th and 17th centuries. Mary may have lived in Egypt in the 1st or 2d century AD.

Aros the Philosopher had a meeting with Mary the Prophetess the Sister of Moyses, and approaching to her, he paid her respect and said unto her, O Prophetess, I have truly heard many say of you that you whiten the Stone in one day.

And Mary said, Yea, Aros, even in a part of one day.

Aros said, O Lady Mary, when will the Work be which you affirm? How shall we whiten and afterwards add blackness?

Mary said, O Aros, oftentimes Nations have dyd about this part. Know you not, O Aros; that there is a water or a thing which whitens Hendragem?

Then Aros answering said to her, O Lady it is so as you say, but in a long time.

Mary answered, Hermes in all his Books has said that the Philosophers whiten the Stone in one hour of the day.

Aros said to her, Oh how excellent is that?

Mary said, it is most excellent to him that is ignorant of it.

Aros said, if men have all the four Elements, he [Hermes] said that their

The bird of Hermes brings the celestial flux to the alchemical dragon, from Elias Ashmole, *Theatrum chemicum britannicum,* 1652.

fumes might be compleated, and complexioned, and coagulated, and retained in one day, untill they doe fullfill the consequence [i.e., attain the end].

Mary said, O Aros, by God, if thy senses or understanding were not solid, you should not hear these words from me, untill the Lord should fill my Heart with the grace of his divine Will. Nevertheless take the Allum of Spain, the white gumm and the red gumm, which is the Kibric of the Philosophers, and their Sol and the greater Tincture, and marry Gumm with Gumm togeather with a true Matrimony. Mary said, make them like a running Water, and vitrify this water which has been laboured or wrought upon for one day, out of the two Lubechs, upon the fixed body, and liquefy them by the secret of Nature in the Vessel of Philosophy. Did you understand us?

Yes Lady.

Mary said, Keep the fume and take care that none of it fly away. And let your measure be with a gentle fire such as is the Measure of the heat of the Sun in the Month of June or July, and stay by your Vessel and behold it with care how it grows black, grows red, and grows white in less than three hours of the day, and the fume will penetrate the body, and the Spirit will be bound up, and they will be like milk, incerating, and liquefying and penetrating: and that is the secret.

Aros said, I do not say that this will be allways.

Mary said unto him, Aros, and this is more wonderfull concerning this, that it was not among the Ancients, nor did it come to him by curing, or by the Medicinall Art and that is take the white, clear and honoured Herb

growing on the Hillocks, and pound it fresh as it is in its Hour, and that is the true Body not flying from the Fire.

And Aros said, it is the Stone of Truth?

And Mary said, yes. But yet men know not this regimen (rule or way of working) with the speediness thereof.

Aros said, and what afterwards.

Mary said, vitrify upon it Kibric or Zibeic and there are the two fumes comprehending the two Lights, and project upon that the complement of the Tinctures of the Spirits, and the weights of Truth, and pound it all, and put it to the Fire, and you shall see wonderfull things from them. The whole government consists in the temper of the Fire, O how strange it is, how it will be moved from one colour to another, in less than an hour of the Day, untill it arrive at the mark of redness and whiteness, and cast away the Fire and permit it to cool, and open it and you will find the clear pearly Body to be of the Colour of the Poppy of the Wood mixt with whiteness and that is it which is incerating, liquefying and penetrating, and one golden piece thereof, the weight of a small golden Coin, falleth upon a thousand thousand and two hundred thousand. That is the hidden secret.

Then Aros fell down upon his face.

And Mary said to him, Lift up your head Aros: because I will shorten for you the thing, as that clear body which is thrown upon the Hillocks, and is not obtained by putrefaction or motion. Take and pound it with Gumm Elsaron, and with the two fumes because the Body comprehending or retaining them is Gumm Elsaron and grind it all. Therefore approach because it all melts. If you project its wife upon it, it will be as a distilling Water, and when the Aire

shall strike it, it will be congealed and be one body, and make projection of it, and you will behold Wonders: O Aros that is the hidden secret of Scholia; and know that the said two fumes are the Root of this Art, and they are the white Kibric and the humid calx, but the fixed Body is of the Heart of Saturn comprehending the Tincture, and the Fields of Wisdom or of Scholia. And the Philosophers have named it by many and all names, and received or gathered from the Hillocks it is a clear white Body, and these are the medicine of this Art, part is procured and part is found upon the Hillocks; and know Aros that the wise men have not called it the Fields of Wisdom, or of Scholia, unless because Scholia will not be compleated but by it; and in the Scholia there are nothing but wonderfull things. For there also enters into them the four Stones, and its true regimen is as I have said. And that is first Scoyare, Ade, and Zethet; by that make your Allegory as Hermes has done in his Books Scoyas, and the Philosophers have allways made the regimen longer, and have resembled the work to every thing which ought not to make the work, and they make the Magistery to be in one year, and this but onely for hiding it from the ignorant people, untill it be confirmed in their Hearts and their senses (till they believe the Art): because the Art will not be compleated except only in Gold; because it is the great secret of God: and they who hear of our secrets doe not verify them (nor believe them to be true), by reason of their ignorance. Did you understand Aros?…

From *The Practise of Mary the Prophetesse in the Alchymicall Art,* British Library ms. Sloane 3641, ff. 1–8, 17th-century manuscript of an older text

Zosimos of Panopolis

A Greek alchemist working in about AD 300 in Upper Egypt, Zosimos wrote numerous texts. Among his works is a treatise that presents alchemical processes in visionary or allegorical terms. Zosimos was much quoted by later writers, and is particularly important for the way in which he ritualized alchemical operations, describing them in a powerful language of symbols.

The composition of the waters, and the movement, and the growth, and the removal and restitution of bodily nature, and the splitting off of the spirit from the body, and the fixation of the spirit on the body are not operations with natures alien one from the other, but, like the hard bodies of metals and the moist fluids of plants, are One Thing, of One Nature, acting upon itself. And in this system, of one kind but many colours, is preserved a research of all things, multiple and various, subject to lunar influence and measure of time, which regulates the cessation and growth by which the One Nature transforms itself.

And saying these things, I slept…

And I saw the same altar in the shape of a bowl and water bubbled at the top of it, and in it were many people endlessly. And there was no one whom I might question outside of the bowl. And I went up to the altar to view the spectacle.

And I saw a little man, a barber, whitened with age, and he said to me, "What are you looking at?"

I answered that I wondered at the boiling water and the men who were burning but remained alive.

And he answered me saying, "The

spectacle which you see is at once the entrance and the exit and the process…"

[And] the boiling increased and the people wailed, I saw a copper man holding a lead tablet in his hand. He spoke aloud, looking at the tablet, "I counsel all those in mortification to become calm and that each take in his hand a lead tablet and write with his own hand and that each bear his eyes upward and open his mouth until his grapes be grown…"

And when I had seen these visions, I woke again and said to myself, "What is the cause of this vision? Is this not the white and yellow water, boiling, sulphurous, divine?…"

And how does the Nature learn to give and to receive? The copper man gives and the water-stone receives; the thunder gives the fire that flashed from it. For all things are woven together and all things are taken apart and all things are mingled and all things combined and all things mixed and all things separated and all things are moistened and all things are dried and all things bud and all things blossom in the altar shaped like a bowl. For each, by method and by weight of the four elements, the interlacing and separation of the whole is accomplished for no bond can be made without method. The method is natural, breathing in and breathing out, keeping the orders of the method, increasing and decreasing. And all things by division and union come together in a harmony, the method not being neglected, the Nature is transformed. For the Nature, turning on itself, is changed. And the Nature is both the nature of the virtue and the bond of the world…

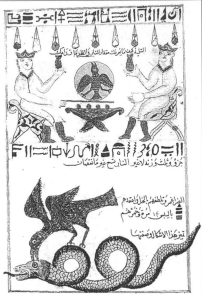

A 17th-century Arabic alchemical manuscript illustrating the double nature of Mercury.

For the priest whom you see seated in the stream gathering his colour, is not a man of copper. For he has changed the colour of his nature, and become a man of silver whom, if you wish, after a little time, you will have as a man of gold…

[Waking], I said, "I understand well that these matters concern the liquids of the art of the metals."

And the one who held the sword said "You have fulfilled the seven steps beneath."

And the other said at the same time as the casting out of the lead by all the liquids, "The Work is completed."

Zosimos of Panopolis,
On Our Art (Ars nostra),
c. AD 300 (?)

The Golden Tractate of Hermes Trismegistus

Another influential text said to be from the ancient and immortal hand of the god Hermes (though its origin is probably Arabic and it is known in a 16th-century Latin edition) was The Golden Tractate. *Herewith an excerpt.*

Understand ye, then, O Sons of Wisdom, that the knowledge of the four elements or the ancient philosophers was not corporally or imprudently sought after, which are through patience to be discovered, according to their causes and their occult operation. But, their operation is occult, since nothing is done except the matter be decompounded, and because it is not perfected unless the colours is thoroughly passed and accomplished. Know then, that the division that was made upon the water by the ancient philosophers separates it into four substances; one into two, and three into one; the third part of which is colour, as it were—a coagulated moisture; but the second and third waters are the Weights of the Wise.

Take of the humidity, or moisture, an ounce and a half, and of the Southern redness, which is the soul of gold, a fourth part, that is to say, half-an-ounce of the citrine Seyre, in like manner, half-an-ounce of the Auripigment, half-an-ounce, which are eight; that is three ounces. And know ye that the vine of the wise is drawn forth in three, but the wine thereof is not perfected, until at length thirty be accomplished.

Understand the operation, therefore. Decoction lessens the matter, but the tincture augments it; because Luna in fifteen days is diminished; and in the third she is augmented. This is the beginning and the end. Behold, I have declared that which was hidden, since the work is both with thee and about thee—that which was within is taken out and fixed, and thou canst have it either in earth or sea.

Keep, therefore, thy Argent vive, which is prepared in the innermost chamber in which it is coagulated; for that is the Mercury which is separated from the residual earth.

He, therefore, who now hears my words, let him search into them; which are to justify no evil-doer, but to benefit the good; therefore, I have discovered all things that were before hidden concerning this knowledge, and disclosed the greatest of all secrets, even the Intellectual Science.

From *"Aureus": The Golden Tractate of Hermes Trismegistus (Septem tractatusseu capitula Trismegisti aurei),* Strasbourg, 1566, edited by John Yarker, 1886

Jābir ibn Hayyān

Known to Europeans as Geber, Jābir ibn Hayyān was one of the great chemists and alchemists of the ancient Arab world. He is said to have written 215 treatises (some say more than three thousand!), several of which survive. These discuss metal refining, dyeing, glassmaking, and other practical matters, as well as more spiritual issues that reflect his esoteric Sufi perspective. He was influenced by Aristotle, and in turn influenced many western alchemists.

Take, for example, glass mixed with mercury in some proportion of weight known to nobody except you, and you give it to the practitioner of Balance. [You will find that] this expert has the capability of determining for you

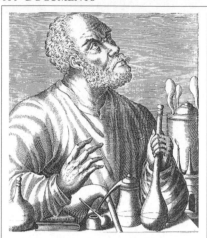

Jābir ibn Hayyān, the great Arab master of the 8th or 9th century, as imagined by a 17th-century illustrator.

Make use of a balance constructed in the manner of the diagrams. This balance is set up by means of three strings going upwards [to the steel beam]: attach two scales to these strings in the usual manner of balance construction, I mean by tying the strings and doing whatever else is needed. Ensure that the middle steel carriage which contains the tongue is located with utmost precision at the center of the beam, so that prior to the tying of the strings the tongue lowers in neither direction even by a single *ḥabba*. Similarly, ensure that the weights of the two scales are equal, that they have equal capacity, and that the quantities of the liquids they hold are likewise equal.

Once you have accomplished all this according to the specific conditions, not much remains to be done. Suspend this balance like ordinary balances. Next, take two vessels with a small depth of the order of a single hand-measure, or less, or more, or however much you wish. Now fill these vessels with water which has already been distilled for several days so that all its impurities and dirt have been removed, the [container] in which this water is kept should have been washed as thoroughly as one washes drinking cups. Having done this, get hold of an ingot of pure, clean, fine gold weighing 1 *dirham,* and an ingot of white, unadulterated, pure silver weighing also 1 *dirham* so that both ingots are equal in weight. Place the gold in one of the scales of the balance, and the silver in the other. Next, immerse the scales in the above-mentioned water until they are totally dipped and submerged.'

Now, note the balance: you will find that the scale carrying the gold

precisely how much of glass the mixture contains, and how much of mercury. The same is true of mixtures of silver and gold, or of copper and silver, or mixtures of three, four, ten, or even a thousand bodies if such a thing is in practice possible.

So we say: The determination of the quantitative composition of mixed bodies is [carried out by means of] a technique which closely approximates the Balance, and it is a splendid technique! Nay, if you were to say that it serves as a demonstration of the faultlessness of this Science, I mean the Science of Balances, you would be speaking the truth, for indeed such is the case. Now, if you wish to know this technique and become an expert of Balance yourself so that when you are given a mixture of bodies and other [solid] substances, you are able to say what substances in what quantities this mixture contains, then in the name of God—

has lowered as compared to the one carrying the silver, and this is due to the smallness of the volume of gold and the largeness of that of silver. This [relative heaviness of gold] results from nothing but the nature dry which it contains. Finally, using counterpoise find out the difference of weight between them, and work out that it is 1½ *dānaqs*. Note that when you mix to this weight of pure gold roughly 1 *qīrāt* or 1 *dānaq* of silver the former will drop in weight in the ratio of *ḥabbas* to *qīrāts,* since there are 12 *ḥabbas* to each *qīrāt.*

So know this, for it is, by my Master, a fountainhead of the knowledge of philosophers! It is in this manner that you determine each one of any two mixed substances, or of any three, four, or five, or however many you will.

For instance, you familiarize yourself with the ratio that exists between gold and copper, silver and copper, gold and lead, silver and lead, and copper, silver, gold and lead. Likewise, you find out the ratio which exists between gold, silver and copper when they are mixed together or between silver, copper and lead. But you can do this by taking one body at a time, or two bodies at a time, or three, or however many you will…

When in a natural object the nature hot is on the opposite side of moist, then we have an instance of the color red. Had this not been the case, the dry due to its preponderance would have torn the moist apart, since [in red bodies] the quantity of dry is enormously greater than that of moist. Reverse is the case with the white, for if [in white bodies] dry had not been on the opposite side of cold, the moist

would have overpowered the dry. The meaning of spatial opposition between the natures is that they exist in mutual proximity; but they do not stand against each other in conflict, I mean in being face-to-face. Nor [are these natures separated from each other] by distance such as that which exists between the circumference of a circle and its center. To be sure, had spatial opposition not existed between the natures (and, consequently, the hot in the red had overpowered [the cold], as is inevitable, and similarly the dry had overpowered [the moist]), then the body in question would have exploded. The same is true of all things which are artificially produced.

Jābir ibn Hayyān (AD 721–815) [Geber], *Kitāb al-Aḥjār [Book of Stones],* published 1994

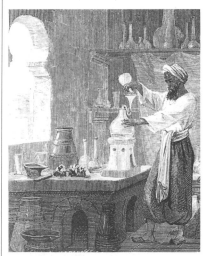

R hasis, an Arabic doctor and alchemist, in his laboratory in Baghdad, in a 19th-century illustration.

The medieval mystics and scientists

In the Middle Ages, European scholars interested in alchemy drew upon both ancient Greek texts and those of the Arabs made familiar to them after the 7th century, mainly through Muslim Spain. Other Arabic texts arrived with returning Crusaders in the 12th century. Byzantine Hellenism also contributed to a flowering of esoteric research in the West.

The *Turba philosophorum*

The Turba philosophorum, *an important medieval alchemical text, was quoted and reprinted extensively by later authors. It represents an imagined conversation among adepts of the ancient world, who discuss the four elements, the metals, and the processes of the Great Work in detail. The following passage is from the conclusion.*

Whosoever does not liquefy and coagulate errs greatly. Therefore, make the earth black; separate the soul and the water thereof, afterwards whiten; so shall ye find what ye seek. I say unto you that whoso makes earth black and then dissolves with fire, till it becomes even like unto a naked sword, who also fixes the whole with consuming fire, deserves to be called happy, and shall be exalted above the circle of the world. This much concerning the revelation of our stone, is, we doubt not, enough for the Sons of the Doctrine. The strength thereof, shall never become corrupted, but the same, when it is placed in the fire, shall be increased. If you seek to dissolve, it shall be dissolved; but if you would coagulate, it shall be coagulated. Behold, no one is without it, and yet all do need it! There are many names given to it, and yet it is called by one only, while, if need be, it is concealed. It is also a stone and not a stone, spirit, soul, and body; it is white, volatile, concave, hairless, cold, and yet no one can apply the tongue with impunity to its surface. If you wish that it should fly, it flies; if you say that it is water, you Speak the truth; if you say that it is not water, you speak falsely. Do not then be deceived by the multiplicity of names, but rest assured that it is one thing, unto which

nothing alien is added. Investigate the place thereof, and add nothing that is foreign. Unless the names were multiplied, so that the vulgar might be deceived, many would deride our wisdom.

From the *Turba philosophorum*, 12th century(?)

The Mirror of Alchemy

Conventionally, the year 1142 is considered the moment when alchemy was born in Europe, with Robert of Chester's translation of texts relating the history of Morienus and King Khalid. Thereafter, alchemy flourished in the Franciscan and Dominican convents of England, France, Germany, and Italy. The English monk Roger Bacon (c. 1220–92), one of the greatest exponents of experimental research in the history of science, was a passionate student of astronomy, mysticism, and alchemy. His work earned him a condemnation for heresy by the church, and his mysterious disappearance from chronicles after 1292 led to the beginning of the enduring legend of the immortality of alchemists.

OF THE DEFINITIONS OF ALCHEMY
…For Hermes said of this Science: Alchemy is a Corporal Science simply composed of one and by one, naturally conjoining things more precious, by knowledge and effect, and converting them by a natural commixtion into a better kind. A certain other said: Alchemy is a Science, teaching how to transform any kind of metal into another: and that by a proper medicine, as it appeared by many Philosophers' Books. Alchemy therefore is a science teaching how to make and compound a certain medicine, which is called Elixir, the which when it is cast upon metals or imperfect bodies, does fully perfect them in the very projection…

OF THE NATURAL PRINCIPLES, AND PROCREATION OF MINERALS
Secondly, I will perfectly declare the natural principles and procreations of Minerals: where first it is to be noted, that the natural principles in the mines, are Argent-vive, and Sulphur. All metals and minerals, whereof there be sundry and diverse kinds, are

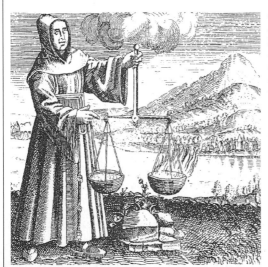

Roger Bacon, Franciscan monk, alchemist, and scientist was one of the first proponents of the experimental research method. For his unorthodox views, he was condemned as a heretic in the 13th century.

begotten of these two: but: I must tell you, that nature always intends and strives to the perfection of Gold: but many accidents coming between, change the metals, as it is evidently to be seen in diverse of the Philosophers books. For according to the purity and impurity of the two aforesaid principles, Argent-vive, and Sulphur, pure, and impure metals are engendered: to wit, Gold, Silver, Steel, Lead, Copper, and Iron...

OUT OF WHAT THINGS THE MATTER
OF ELIXIR MUST BE MORE NEARLY
EXTRACTED

...Now let us return to the imperfect matter that must be chosen and made perfect. Seeing that by the former Chapters we have been taught, that all metals are engendered of Argent-vive and Sulphur, and how that their impurity and uncleanness does corrupt, and that nothing may be mingled with metals which have not been made or sprung from them, it remains clean

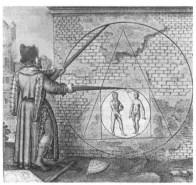

A n engraved emblem from Michael Maier, *Atalanta fugiens*, 1618. Maier writes, "Everyone understands that this squaring [of the circle] is physical and is suited to nature."

enough, that no strange thing which has not its original from these two, is able to perfect them, or to make a Change and new transmutation of them: so that it is to be wondered at, that any wise man should set his mind upon living creatures, or vegetables which are far off, when there be minerals to be found near enough: neither may we in any way think, that any of the Philosophers placed the Art in the said remote things, except it were by way of comparison: but of the aforesaid two, all metals are made, neither does any thing cleave unto them or is joined with them, nor yet changes them, but that which is of them, and so of right we must take Argent-vive and Sulphur for the matter of our stone: Neither does Argent-vive by itself alone, nor Sulphur by itself alone, beget any metal, but of the commixtion of them both, diverse metals and minerals are diversely brought forth.

Our matter therefore must be chosen of the commixtion of them both: but our final secret is most excellent, and most hidden, to wit, of what mineral thing that is more near than others, it should be made: and in making choice hereof, we must be very wary....

Finally,...we should mix everything as it is, according to a due proportion, which no man knows, and afterward decoct it to coagulation, into a solid lump: and therefore we are excused from receiving both of them in their proper nature: to wit, Argent-vive and Sulphur, seeing we know not their proportion, and that we may meet with bodies, wherein we shall find the said things proportioned, coagulated and gathered together, after a due manner.

Keep this secret more secretly. Gold

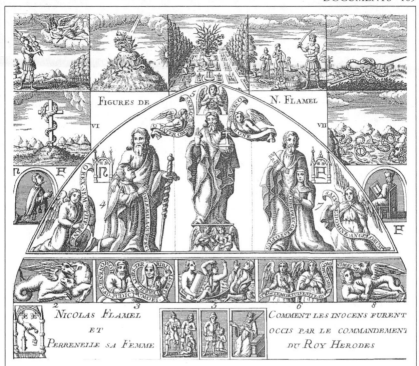

FIGURES DE N. FLAMEL

NICOLAS FLAMEL
ET
PERRENELLE SA FEMME

COMMENT LES INOCENS FURENT
OCCIS PAR LE COMMANDEMENT
DU ROY HERODES

An illustration of the figures that once adorned the tombstone of Nicolas Flamel and his wife, Pernelle, both alchemists, in the Cemetery of the Innocents in Paris. This was destroyed in 1797, during the French Revolution. Above these are seven figures from the mysterious *Book of Abraham,* described by Flamel in his own *Livre des figures hiéroglyphiques.*

is a perfect masculine body, without any superfluity or diminution: and if it should perfect imperfect bodies mingled with it by melting only, it should be Elixir to red. Silver is also a body almost perfect, and feminine, which if it should almost perfect imperfect bodies by his common melting only, it should be Elixir to white which it is not, nor cannot be, because they only are perfect. And if this perfection might be mixed with the imperfect, the imperfect should not be perfected with the perfect, but rather their perfections should be diminished by the imperfect, and become imperfect. But if they were more than perfect, either in a two-fold, four-fold, hundred-fold, or larger proportion, they might then well perfect the imperfect.

Roger Bacon,
*The Mirror of Alchemy,
composed by the thrice-famous and
learned fryer, Roger Bachon,*
published 1597

The triumph of Hermetism in the Renaissance

If the 14th century saw an emerging taste for Hermetism, the 15th witnessed a veritable passion for it. The courts of Europe entertained astrologers and alchemists; noble libraries collected their works. By the 16th century, alchemy had influenced many aspects of European culture. In Rome, the humanist Giordano Bruno (1548–1600) incorporated Hermetic ideas into his philosophy. In London, John Dee (1527–1608), astrologer to Queen Elizabeth I, studied the transmutation of metals. In Prague, the Holy Roman Emperor Rudolph II (1552–1612) was a passionate student of esotericism and drew alchemists to his court, where he assembled one of the finest libraries of Hermetic texts. Queen Christina of Sweden (1626–89) became an ardent patron of alchemists.

The Neoplatonists of Florence

At the court of the Medici rulers of Florence, Marsilio Ficino (1433–99) led a circle of philosophers and poets called the Platonic Academy and translated the Corpus hermeticum. *There and elsewhere, alchemy became a theme in Renaissance art and philosophy.*

CHAPTER 2: OF NATURE AND ART
…There are two sorts of Philosophers. Some only searching into Nature by herself, have in the monuments of their writings delivered the virtue and power which sublunary things have, as well from the elemental qualities, as from heaven and the stars; as the physicians are. And some others who have described the natures of animals, trees, herbs, metals, and precious stones. But others truly are more glorious, penetrating most sagaciously and sharply not only into Nature, but finally into the arcanum itself of Nature, and into her more inward recesses, have by a truer title assumed to themselves the name of philosopher. But because Nature produces all metals out of two things, sulphur and Mercury, and has left us the superior bodies generated out of them, with the inferior bodies, certain it is that the industrious may make the same out of her three operations, and reduce the inferior bodies to the Nature and perfection of the superior bodies…

CHAPTER 4: DELIVERS WHY THE PHILOSOPHERS HAVE SOUGHT FOR THIS ART, NOT MOVED THEM TO IT, AND THIS QUESTION IS RESOLVED: WHY THE SPIRIT IN METALS CANNOT PROPAGATE ITS LIKE, SINCE THE SPIRIT OF EVERYTHING IS THE AUTHOR OF GENERATION
But we readily affirm that the inspiration of God was the chief cause why those

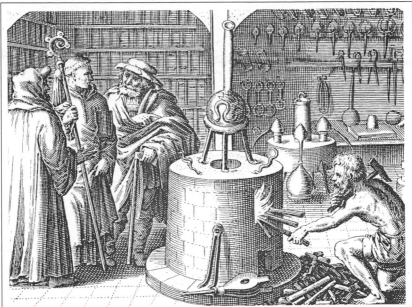

Three great alchemists, the Benedictine Basil Valentine, Thomas Norton, and John Cremer, abbot of Westminster, converse before the Athanor. The engraving is from a book by Michael Maier, *Tripus aureus*, 1618, that contains the writings of these three churchmen.

ancient philosophers searched after this science… the philosophers thought to bring the light and lustre of the most perfect body into the inferior bodies since they had found that they differed among themselves only according to the decoction, either greater or less, and the mercury was the first original of all metals, with which mercury extracting the metallic part of gold, they brought gold to the first nature. Which reduction indeed since it is easy and possible, it was by the philosophers concluded that a transmutation in metals is easy and possible. And when these primitive philosophers had reduced gold into the first matter, they made use of the celestial influence, that it might not be made a metal again such as it was before. Afterward they purified its nature, separating the unclean from the clean. Which being done they called that thing, the transmuting stone of the philosophers. For the making whereof several operations have been invented by several philosophers, that that might be completed by art which was left by Nature; since Nature herself is always inclined toward her own perfection…

From *Marsilio Ficino on the Alchemical Art*, ms. Sloane 3638, British Library, London, 1518, translation of Marsilio Ficino, *Liber de arte chemica*

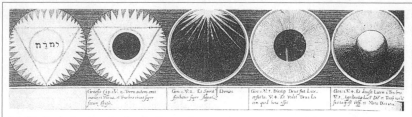

Genesis (32 c. 2: Terra autem erat inanis et Vacua, et Tenebræ erant super faciem Abyssi.

Gen: 1. V. 2. Et Spirit' ferebatur super Aquas.

Gen: 1. V. 3. Dixitq; Deus fiat Lux, refecta. V. 4. Et Vidit Deus Lucem quod bona esset.

Gen: 1. V. 4. Et divisit Lucem à Tenebris V.5. Appellauitq; Lucem Diem et Tenebras noctem factumq; est Vesp; et Mane Dies una.

This illustration from Lambsprinck's 1625 *Musaeum hermeticum* recounts the creation of the world in ten medallions, up to the appearance of Adam and Eve, who are represented in the

Two Renaissance esoteric philosophers

The Swiss physician Paracelsus (1493–1541) and the mysterious Basil Valentine (15th or 16th century) were among the esoteric researchers who published important texts on alchemical practices.

ON MINERAL SULPHUR

Now I must write about the miracles of the qualities of sulphur in alchemy. Many have tried various arts, trying to make something from sulphur which would be more than sulphur itself. But God has created art in such a way that it can do it. As the power of art can do it, the master has followed that art and tried to find out what can be made of sulphur which is not in sulphur or has tried to find out if it might lead to something else. It is like a woman who in herself cannot bring forth children, but who, together with her husband, does. If art can bear a little more and if they do something together, then the artist is the man and father who causes all…

Now the art went on searching, trying to make silver from the white and gold from the red. I know that nothing has ever been made from the crude or milk sulphur, either by the ancients or by the moderns. Therefore, I say that this is a dead milk with nothing in it. But mark what I say about the red oil [of

sulphur]…[A] ruby which is not highly graded and which is put into the red oil for nine years becomes so pure and clear and reaches such a grade that, if later it is put into darkness, it gives light like a coal, so that you can see from all around where it is lying. This has been proved by experience. The old alchemists made carbuncle out of it;…

It should also be known that every kind of silver put into it and left to lie there for a time turns black and gives a chalk sediment, not steady and fixed, but unsteady and volatile. If it has been there all its term, and the end comes, it does all that can be done; it is of no use to speak more of it. Remember that sulphur if brought to the right grades becomes more subtle, finer, stronger, quicker in its effect, and better. This is the effect of the tincture on stones and metals…

Theophrastus Bombast von Hohenheim, called Paracelsus, *On the Alchemistic Virtues of Sulphur: First, On the Embrionic Sulphur*, 16th century, translated by Gregory Zilboorg

The Fire Stone which is prepared from Antimony, which also I have promised to describe, does not only cure the diseases of men, but it removes the imperfections of metals. I must proceed to tell you what the Fire Stone is; what

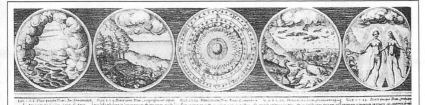

last scene as the man-sun and woman-moon, the primordial alchemical couple.

is its ore; whether it can be prepared without a proper substance; wherein consists the difference of the stones; how many kinds of them there are; and, finally, what are their uses. May God illumine my mind by His Holy Spirit that I may perform this task aright, and be able to appear before Him with a clear conscience on the day of judgment, when sentence will be pronounced upon the lives of all men!

Above everything you should know that the true tincture of Antimony, which is the Medicine of men and metals, is not prepared from crude, melted Antimony, which is bought in shops, but from the ore of Antimony, as it is dug up from the mine, and is first formed into glass. The great and important question is: How is this tincture extracted? Know also that the prepared, fixed, and sold tincture of Antimony, or Fire Stone, as I prefer to name it, is a pure essence of penetrative, spiritual, and igneous quality, and is reduced into a coagulated substance, which, like the salamander, rejoices in the fire as in its own proper element.

But the Fire Stone is not an universal Tincture, like the Philosopher's Stone, which is prepared from the essence of gold. Our Fire Stone tinges silver into gold, and also perfects tin and lead, but does not transmute iron and copper, nor does it impart to them more than can be obtained from them by separation. One part of this tincture has no power to transmute more than five parts of any imperfect metal. The great Philosopher's Stone, on the other hand, has infinite power of transmutation. Yet the precious metal produced by the Fire Stone is pure and solid gold.

The ore from which this tincture is prepared is, as I have already stated, the earth of Antimony. In the meantime, let the reader observe that there are many kinds of stones, which tinge in a particular way. All fixed powders that have the power of tinging, I call Stones. The first and foremost of all Stones is the Philosopher's Stone; then comes the Tincture of the Sun and Moon in the white; then the Tincture of Vitriol or Venus; and also the Tincture of Mars. The two latter include the Tincture of the Sun. Then come the Tinctures of Jupiter and Saturn, for the coagulation of Mercury, and, finally, the Tincture of Mercury itself. All these different Tinctures are generated from one original mother, to which the great Universal Tincture also owes its birth; but apart from these there are no other tinctures...

Basil Valentine,
The Triumphal Chariot of Antimony,
published 1685,
edited by A. E. Waite, 1893

Alchemy in the modern era

Despite its arcane reputation and ancient sources, alchemy remains alive in the modern world and is practiced as both a practical and a spiritual discipline. It has attracted the interest of a wide range of scholars, from the pioneering psychologist C. G. Jung to the historian of religions Mircea Eliade. And contemporary alchemists continue to write esoteric texts.

A mystery in the modern world

Between 1926 and 1929, two volumes, The Mysteries of the Cathedrals *and* The Dwellings of the Philosophers, *were published in Paris, authored by a mysterious personage named Fulcanelli, said to have been born in 1838.... Little is known of this alchemist; he is often said to be Jean-Julien Champagne (1877–1932). His books exhibit a deep knowledge both of the texts of alchemy and its practical operations and his teachings are extremely influential. Here, he makes a distinction between an ancient practice he calls "archemy," the predecessor of modern chemistry, and the divinely inspired ineffable art called alchemy.*

There were in the Middle Ages and possibly even in Greek antiquity, if we refer to the works of Zosimos and Ostanes—two degrees, two orders of research in chemical science: *spagyry and archemy*. These two branches of the same *exoteric* art spread throughout the working class by means of laboratory practice. Metallurgists, goldsmiths, painters, ceramic artists, glassmakers, dyers, distillers, enamelers, potters, etc., had, as much as apothecaries, to be provided with sufficient spagyric

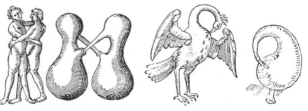

Engravings of the vessels and their associated symbols from Giambattista della Porta, *De distillatione,* 1609. Della Porta (1535?–1615) was a founder of the Accademia dei Secreti and member of the Accademia dei Lincei in Rome, two important societies engaged in esoteric and alchemical research.

knowledge. They perfected this knowledge themselves later on in the exercise of their profession. As for archemists, they formed a special category, more restricted, more obscure also, among the ancient chemists. The aim which they pursued presented some analogy with that of the alchemists, but the materials and the means which they had at their disposal were uniquely *chemical* materials and means. To transmute metals into one another, to produce gold and silver from coarse minerals, or from saline metallic compounds, to force the gold potentially contained in silver and silver potentially contained in tin to become real and extractable, was what the archemist had in mind....And since medieval laws forbade private possession of furnaces and chemical utensils without preliminary permission, many artisans, their work once finished, studied, manipulated, and secretly experimented in their cellars or their attics. They cultivated the science of the *little particulars*,

according to the somewhat disdainful expression of the alchemists for these side activities unworthy of the philosopher...

Nevertheless, in spite of their errors—or rather because of them—it is they, the archemists, who provided first the spagyrists and later modern chemistry with the facts, methods, and operations they needed. These men, tormented with a desire to search everywhere and to learn everything, are the true founders of a splendid and perfect science to which they bestowed accurate observations, exact reactions, skillful manipulations, and painfully acquired techniques. Let us humbly salute these pioneers, these precursors, these great workers, and let us never forget what they did for us.

However, we repeat, alchemy has nothing to do with these successive contributions. Hermetic writings alone, misunderstood by profane investigators, were the indirect cause of discoveries which their authors had never anticipated. It is in this manner that

The directors of the Alchemical and Astrological Society of France in their laboratory, 1903.

Blaise de Vigenère obtained benzoic acid by sublimating benzoin; that Brandt could extract phosphorus by seeking the alkahest in urine; that Basil Valentine, a prestigious Adept who did not despise spagyric experiments, established the entire series of antimonial salts and the colloid of ruby gold; that Raymond Lully prepared acetone, and Cassius the purple of gold; that Glauber obtained sodium sulphate and Van Helmont recognized the existence of gases. But, with the exception of Lully and of Basil Valentine, all these researchers, wrongly classified among alchemists, were simple archemists or learned spagyrists....

With their confused texts, sprinkled with cabalistic expressions, the books remain the efficient and genuine cause of the gross mistake that we indicate. For, in spite of the warnings, the objurgations of their authors, students persisted in reading them according to the meanings that they hold in ordinary language. They do not know that these texts are *reserved for initiates*, and that it is essential, in order to understand them, to be in possession of their secret key. One must first work at discovering this key. Most certainly these old treatises contain, if not the entire science, at least its philosophy, its principles, and the art of applying them in conformity with natural laws. But if we are unaware of the hidden meaning of the terms—for example, the meaning of *Ares*, which is different from *Aries* and is closer to *Arles*, *Arnet*, and *Albait*—strange qualifications purposely used in the composition of such works, we will understand nothing of them or we will be infallibly led into error. We must not forget that it is an *esoteric science*. Consequently, a keen

intelligence, an excellent memory, work, and attention aided by a strong will are not sufficient qualities to hope to become learned in this subject...Batsdorff, in the beginning of his treatise, charitably warns the reader in these terms "...I beg those who will read this little book to credit my words. I say to them once more, that they will never learn this sublime science by means of books, and that *it can only be learned through divine revelations,* hence it is called *Divine Art,* or through the means of a good and faithful master; and since there are very few of them to whom God has granted this grace, there are also very few who teach it."...

The simplest archemic process consists in using the effect of violent reactions—that of acids on bases— so as to provoke, in the midst of the effervescence, the reunion of the pure parts, their irreducible combination under the form of new bodies. It is then possible, from a metal close to gold— silver preferably—to produce a small quantity of the precious metal. Here is, in this order of experiment, an elementary operation whose success we certify provided our instructions are closely followed.

Pour into a tall tubular glass retort a third of its capacity of pure nitric acid. Attach to it a receiver with an exhaust tube and set the apparatus on a sand bath. Operate under a *fume hood.* Heat the apparatus gently without reaching the boiling point of the acid. Then stop the heat, open the neck and introduce a thin fraction of virgin or cupeled silver that contains no traces of gold. When the emission of nitric peroxide ceases and the effervescence has calmed down, allow a second portion of pure silver to fall into the liquor. Thus repeat

An alchemical vessel and its symbolic animal in an engraving from Giambattista della Porta, *De distillatione*, 1609.

the introduction of the metal, without haste, until the boiling and the emission of red fumes manifest only little energy, signs of approaching saturation. Add nothing more. Let it settle for a half hour, then cautiously decant your clear, still-warm solution into a beaker. You will find at the bottom of the retort a thin deposit in the form of *fine black sand.* Wash it with lukewarm distilled water and let it drop into a small porcelain capsule. You will find out through testing that this precipitate is insoluble in hydrochloric acid, as it is in nitric acid. Aqua regia dissolves it and yields a magnificent yellow solution, absolutely similar to that of gold trichloride. Dilute this liquor with distilled water; precipitate it with a sliver of zinc; an amorphous powder, very fine, dull, or reddish-brown coloration will be deposited, identical with that given by natural gold reduced in the same manner. Properly wash, and then dry this powdery precipitate. By pressing it on a sheet of glass or marble, you will get a brilliant, coherent lamina, of a beautiful yellow shine in reflection, of a green color in transparency, having the appearance and the superficial characteristics of the purest gold.

In order to augment your minute deposit with a new quantity, you can do this operation as many times as you wish. In this case, take again the clear silver nitrate solution, diluted by the waters of the first washing; reduce the metal with zinc or copper; decant and abundantly wash when the reduction is complete. Dry this powdery silver and use it for your second dissolution. By continuing in this manner, you will amass enough metal to render the analysis much easier. Furthermore, you will be assured of its true production— even if the silver that you originally used had some traces of gold.

But this simple body, so easily obtained, although in a very small proportion, is it truly gold? Our sincerity compels us to say *no* or, at least, not yet. For even if it shows the most perfect outer analogy to gold, and even most of its properties and chemical reactions, still one essential physical characteristic is missing: density. This gold is less heavy than natural gold, although its own density is already greater than that of silver. We can therefore regard it as, not the representative of a more or less unstable allotropic state of silver, but rather as a young, or *nascent gold,* which further reveals its recent formation. Moreover, the newly produced metal remains capable of taking and keeping, by *contraction,* the increased density that the adult metal possesses. Archemists used a process which ensured the nascent gold all the specific qualities of adult gold; they called this technique *maturation* or *firming up,* and we know that mercury was its principal agent....

Hermetic philosophy teaches us that

bodies have no action on bodies and that *only spirits are active and penetrating.* It is they, these spirits, these natural agents, that provoke in the midst of matter the transformations which we observe there. Yet wisdom demonstrates through experimentation that bodies cannot form among themselves anything but easily reducible, temporary combinations. Such is the case of alloys, some of which are liquefied by simple fusion, and of all saline compounds. Similarly, alloyed metals maintain their specific qualities in spite of the diverse properties which they take on in the state of association. We can then understand of what usefulness the spirits can be in releasing the metallic sulphur or mercury when we know that they alone are capable of overcoming the strong cohesion which tightly binds these two principles between themselves.

It is essential first to understand what the Ancients meant by the generic and rather vague term of *spirits.*

For the alchemists, the spirits are *real influences,* although they are physically almost immaterial or imponderable. They act in a mysterious, inexplicable, unknowable but efficacious manner on substances submitted to their action and prepared to receive them. Lunar radiation is one of these hermetic spirits…

But this is enough. Let whoever wants to work, work: we care little whether one maintains his opinion, follows or despises our advice. We will repeat one last time that of all the operations benevolently described in these pages, none can be related in any way to *traditional alchemy;* none can be compared to its own operations. A thick wall separates the two sciences, an insurmountable obstacle for those who are familiar with the methods and the formulas of chemistry. We do not want to make anyone despair, but truth compels us to say that those who keep on performing spagyric research will never come out of the ways of official chemistry. Many modern chemists believe in good faith that they are resolutely going far from chemical science, because they explain its phenomena in a special manner without using any other technique besides that of the learned men whom they criticize. Alas, there have always been many of these erring and self-deluded people, and it is perhaps for them that Jacques Tesson wrote these words of truth: "Those who want to accomplish our Work through digestions, through common distillations, and similar sublimations, and others by triturations, *all these people are off the good path,* in great error and difficulty, and they will never succeed because all these names, words, and manners of operation are names, words, and manners of metaphor."

We believe that we have fulfilled our purpose and demonstrated, as much as it has been possible to do so, that the *ancestor of modern chemistry is not the old and simple alchemy but ancient spagyrics,* enriched with successive contributions from Greek, Arabic, and medieval archemy.

If one wants to have some idea of the secret science, let him bring his thoughts back to the work of the farmer and that of the microbiologist, since ours is placed under the dependence of analogous *conditions.* For, as Nature gives the farmer the earth and the grain, and the microbiologist the agar-agar and the spore, similarly she gives the

alchemist the proper metallic terrain and the appropriate seed. If all the *circumstances* favorable to the regular process of this special culture are rigorously observed, the harvest cannot but be abundant...

In summary, alchemical science, of an extreme simplicity in its materials and its formula, nevertheless remains the most unrewarding, the most obscure of all, by reason of the exact knowledge of the required conditions and the required *influences.* There is its mysterious side, and it is towards the solution of this most difficult problem that the efforts of all the sons of Hermes converge.

Fulcanelli,
The Dwellings of the Philosophers, 1930,
translated by Brigitte Donvez and
Lionel Perrin

The continuity of alchemical research

Fulcanelli's best-known student was Eugène Canseliet (1899–1982). Some scholars have suggested that the older master's books were written by him, from notes. In a preface to one of Fulcanelli's texts, Canseliet reviews the history of alchemy.

Long considered a chimera, alchemy appeals to the scientific world more and more every day. The works of scientists on the constitution of matter and their recent discoveries show and give evidence of the dissociation potential of chemical elements. Nowadays, no one any longer doubts that the elements, once regarded as simple, are in fact compounds, and the hypothesis of atomic indivisibility no longer finds any partisans. The deceptive concept of inertia disappears from the Universe, and that which only yesterday seemed heresy has today become dogma. With

an impressive uniformity of action, but in varying degrees, life manifests itself in the three kingdoms of nature, once clearly separated, and among which there is no longer any distinction made. Origin and vitality are shared by the triple group of the ancient classification. Crude substance proves to be animate. Beings and things evolve, progress through constant transformations and new beginnings. Through the multiplicity of their exchanges and combinations, they separate themselves from the original unity, only to reassume their original simplicity under the influence of decompositions. Sublime harmony of the great Totality, immense circle through which the Spirit goes in its eternal activity and which has for center

The 20th-century alchemist Eugène Canseliet, engaged in the Work in his laboratory.

the unique living fragment, emanating from the creative Logos.

And so, after having strayed from the correct path, modern science seeks to rejoin it, progressively adopting ancient concepts. Much like successive civilizations, human progress obeys the inescapable law of perpetual renewal. Though it be against all, Truth always triumphs, in spite of its slow, painful, and tortuous advance. Sooner or later common sense and simplicity gets the better of sophistry and prejudices. "For there is nothing," the Gospel teaches, "which cannot be discovered and nothing so secret that it cannot be known." (Matt. 10:26)

Yet, we should not believe that traditional science, whose elements Fulcanelli assembled, has been adapted for the general public in the present work. The author makes no such pretense. He would greatly delude himself who hoped to understand the secret doctrine after a simple reading. "Our books have not been written for all," repeat the old masters, "though all are called upon to read them." For each one of us must contribute his personal effort which is definitely essential if he wants to acquire the notions of a science which has never ceased to be esoteric. This is why the philosophers, aiming to hide its principles from the masses, have concealed the ancient knowledge in the mystery of words and the veil of allegories.

The ignoramus will not so easily forgive alchemists their allegiance to the rigorous discipline they have freely accepted. I know my master cannot shun this same criticism. Before all, he had to respect the divine will, giver of light and revelation. He also owed obedience to the philosophers' law which imposes upon initiates the necessity of inviolable secrecy.

In antiquity, and especially in Egypt, this primordial submission applied to all branches of science and the industrial arts. Potters, enamellers, goldsmiths, foundry workers, glass workers, worked inside of temples. The working personnel of workshops and laboratories were part of the priestly class and answered directly to the priests. From the Middle Ages up to the 19th Century, history shows us numerous examples of similar organizations in chivalry, the monastic orders, free-masonry, trade guilds, etc. These many professional associations jealously guarded the secrets of their science or their trades; they always maintained a mystical or symbolic character, kept traditional customs, and practised religious ethics. We know the tremendous respect which the gentlemen glassworkers enjoyed with kings and princes, and to which extent they took care to prevent the circulation of the secrets specific to the noble industry of glassmaking.

These exclusionary rules have a profound reason. If I were to be asked, I would simply say that the privilege of science should remain the prerogative of a scientific elite. The most beautiful discoveries prove to be more harmful than useful once they have fallen into the popular domain, and are distributed without discernment to the masses and blindly exploited by them. Man's nature pushes him voluntarily towards evil and the worse. More often than not, that which could bring him well-being turns to his disadvantage and eventually becomes the instrument of his ruin. Methods of modern warfare are, alas! the most striking and the saddest proof

LA NATURE À DÉCOUVERT

Pour les Enfans de la Science seulement
et non pour les Ignorants Sophistes

PAR

LE CHEVALIER INCONNU

LA NATURE À DÉCOUVERT

La Sainte Écriture appelle la matière première, tantôt une terre vague et stérile, et tantôt Eau. La division a été faite des eaux supérieures des inférieures, en séparant le subtil de l'épais, et le léger comme un esprit du corps matériel. Cet œuvre a été accomplie par l'Esprit du corps lumineux; car la lumière est un esprit igné qui, en séparant les hétérogènes, a chassé en bas les mauvaises ténèbres de la région voisine, et est plus éminente et plus éclatante; et amassant la matière homogène et subtile, est plus approchante de l'Esprit et l'a allumée en lumière immortelle et, comme une huile incombustible, devenant le trésor de la Divine Majesté, c'est le Ciel empyrée qui est entre le monde intelligible et le monde matériel, comme l'horizon et le

Nature Discovered: For the Children of Science Alone and Not for Ignorant Sophists, a publication by Eugène Canseliet issued under the pseudonym of the Chevalier Inconnu, or "anonymous knight."

necessary pieces of knowledge. Thus equipped, he will then be able to attempt his great work and leave the speculative domain for that of positive realizations.

of this disastrous state of mind. *Homo homini lupus.* For the mere reason that they used overly obscure language, it would be unfair in the face of so serious a danger to bury the memory of our great ancestors under a reprobation that they do not deserve. Must we condemn them all and despise them, only for the fact that they showed too much restraint? By shrouding their works in silence and their revelations in parables, the philosophers acted wisely. Respectful of social institutions, they harm no one and ensure their own safety...

Among ancient authors and modern writers, Fulcanelli is without doubt one of the most sincere and the most convincing. He establishes the hermetic theory on a solid basis, supports it with evident analogical facts, and then presents it in a simple and precise manner. To discover on what ground the principles of the art have been laid, the student, because of the clear and firm development, only needs to make a few efforts. He will even be able to accumulate a great number of the

From this moment on, he will encounter the first difficulties, and he will have to clear numerous and practically insurmountable obstacles. There is not a researcher who doesn't know these stumbling blocks, these insurmountable limits against which I myself, several times, nearly failed. Of this, my master has kept the permanent memory, even more than I did. Much like Basil Valentine, his true initiator, he was held in check without being able to find a solution for more than thirty years!

Fulcanelli elaborated on the practical details much further than anyone else, out of charity for the workers, his brothers, in order to help them vanquish these tiring causes of interruption. His method is different from that employed by his predecessors; it consists in describing in detail all the operations of the Work, after having divided them into several fragments. He thus takes each of the phases of the Work, begins its explanation in a chapter, interrupts it to continue it in

another, and completes it in a final passage. This parceling out, which turns the Magistery into a philosophical puzzle, will not frighten the educated investigator; but it quickly discourages the layman, incapable of finding his way in this labyrinth of a different nature, and unqualified to uncover the correct sequence of the manipulations.

Eugène Canseliet, preface to the first edition of Fulcanelli, *The Dwellings of the Philosophers*, 1930, translated by Brigitte Donvez and Lionel Perrin

Alchemy and the psyche

The psychologist C. G. Jung interpreted alchemy in metaphoric and spiritual terms. For him, as for the alchemists themselves, the transmutation of base metal into gold symbolized the human being's effort toward self-realization. Jung links alchemical processes and symbols to religious archetypes as well as to dream interpretation.

Until quite recently science was interested only in the part that alchemy played in the history of chemistry, concerning itself very little with the part it played in the history of philosophy and religion. The importance of alchemy for the historical development of chemistry is obvious, but its cultural importance is still so little known that it seems almost impossible to say in a few words wherein that consisted...

Slowly, in the course of the eighteenth century, alchemy perished in its own obscurity. Its method of explanation— "obscurum per obscurius, ignotum per ignotius" (the obscure by the more obscure, the unknown by the more unknown)—was incompatible with the spirit of enlightenment and particularly with the dawning science of chemistry

towards the end of the century... [A] century earlier, at the time of Jakob Böhme,...many alchemists deserted their alembics and melting-pots and devoted themselves entirely to (Hermetic) philosophy. It was then that the chemist and the Hermetic philosopher parted company...This was a time when the mind of the alchemist was still grappling with the problems of matter, when the exploring consciousness was confronted by the dark void of the unknown, in which figures and laws were dimly perceived and attributed to matter although they really belonged to the psyche. Everything unknown and empty is filled with psychological projection; it is as if the investigator's own psychic background were mirrored in the darkness. What he sees in matter, or thinks he can see, is chiefly the data of his own unconscious which he is projecting into it. In other words, he encounters in matter, as apparently belonging to it, certain qualities and potential meanings of whose psychic nature he is entirely unconscious. This is particularly true of classical alchemy, when empirical science and mystical philosophy were more or less undifferentiated. The process of fission which separated the *physical* from the *mystical* set in at the end of the sixteenth century and produced a quite fantastic species of literature whose authors were, at least to some extent, conscious of the psychic nature of their "alchemystical" transmutations...

Alchemy, as is well known, describes a process of chemical transformation and gives numberless directions for its accomplishment. Although hardly two authors are of the same opinion regarding the exact course of the process and

the sequence of its stages, the majority are agreed on the principal points at issue, and have been so from the earliest times, i.e., since the beginning of the Christian era. Four stages are distinguished, characterized by the original colours mentioned in Heraclitus: *melanosis* (blackening), *leukosis* (whitening), *xanthosis* (yellowing), and *iosis* (reddening)… Later, about the fifteenth or sixteenth century, the colours were reduced to three… Whereas the original tetrameria corresponded exactly to the quaternity of elements, it was now frequently stressed that although there were four elements (earth, water, fire, and air) and four qualities (hot, cold, dry, and moist), there were only three colours: black, white, and red. Since the process never led to the desired goal and since the individual parts of it were never carried out in any standardized manner, the change in the classification of its stages cannot be due to extraneous reasons but has more to do with the symbolical significance of the quaternity and the trinity; in other words, it is due to inner psychological reasons.

The *nigredo* or blackness is the initial state, either present from the beginning as a quality of the *prima materia,* the chaos or *massa confusa,* or else produced by the separation (*solutio, separatio, divisio, putrifactio*) of the elements. If the separated condition is assumed at the start, as sometimes happens, then a union of opposites is performed under the likeness of a union of male and female (called the *coniugium, matrimonium, coniunctio, coitus*), followed by the death of the product of the union (*mortificatio, calcinatio, putrifactio*) and a corresponding *nigredo*. From this the washing (*ablutio,*

baptisme) either leads direct to the whitening (*albedo*), or else the soul (*anima*) released at the "death" is reunited with the dead body and brings about its resurrection, or again the "many colours" (*omnes colores*), or "peacock's tail" (*cauda pavonis*), lead to the one white colour that contains all colours. At this point the first main goal of the process is reached, namely the *albedo, tinctura alba, terra alba foliata, lapis albus,* etc., highly prized by many alchemists as if it were the ultimate goal. It is the silver or moon condition, which still has to be raised to the sun condition. The *albedo* is, so to speak, the daybreak, but not till the *rubedo* is it sunrise. The transition to the *rubedo* is formed by the *citrinitas,* though this, as we have said, was omitted later. The *rubedo* then follows direct from the *albedo* as the result of raising the heat of the fire to its highest intensity. The red and the white are King and Queen, who may also celebrate their "chymical wedding" at this stage…

The alchemical *opus* deals in the main not just with chemical experiments as such, but with something resembling psychic processes expressed in the pseudochemical language. The ancients knew more or less what chemical processes were; therefore they must have known that the thing they practised was, to say the least of it, no ordinary chemistry…If the alchemist is admittedly using the chemical process only symbolically, then why does he work in a laboratory with crucibles and alembics? And if, as he constantly asserts, he is describing chemical processes, why distort them past recognition with his mythological symbolisms?…

The real mystery does not behave

mysteriously or secretively; it speaks a secret language, it adumbrates itself by a variety of images which all indicate its true nature. I am not speaking of a secret personally guarded by someone, with a content known to its possessor, but of a mystery, a matter or circumstance which is "secret," i.e., known only through vague hints but essentially unknown. The real nature of matter was unknown to the alchemist: he knew it only in hints. In seeking to explore it he projected the unconscious into the darkness of matter in order to illuminate it. In order to explain the mystery of matter he projected yet another mystery—his own unknown psychic background—into what was to be explained: *Obscurum per obscurius, ignotum per ignotius!* This procedure was not, of course, intentional; it was an involuntary occurrence.

...As we all know, science began with the stars, and mankind discovered in them the dominants of the unconscious, the "gods," as well as the curious psychological qualities of the zodiac: a complete projected theory of human character. Astrology is a primordial experience similar to alchemy. Such projections repeat themselves whenever man tries to explore an empty darkness and involuntarily fills it with living form.

C. G. Jung,
Psychology and Alchemy, 1944,
translated by R. F. C. Hull, 1968

Alchemy in the history of religions

A contemporary historian of religions looks at alchemy from a cross-cultural perspective.

If, therefore, alchemy could not be born from the desire to counterfeit gold

(gold assay had been known for at least twelve centuries), nor from a Greek Scientific technique (we have just seen the alchemists' lack of interest in physico-chemical phenomena as such) we are compelled to look elsewhere for the origins of this discipline *sui generis.* Much more than the philosophic theory of the unity of matter, it was probably the old conception of the Earth-Mother, bearer of embryo-ores, which crystallized faith in artificial transmutation (that is, operated in a laboratory). It was the encounter with the symbolisms, myths and techniques of the miners, smelters and smiths which probably gave rise to the first alchemical operations. But above all it was the experimental discovery of the *living* Substance, such as it was felt by the artisans, which must have played the decisive role. Indeed, it is the conception of a *complex and dramatic Life of Matter* which constitutes the originality of alchemy as opposed to classical Greek science. One is entitled to suppose that the *experience* of *dramatic life* was made possible by the knowledge of Graeco-oriental mysteries.

It is known that the essence of initiation into the Mysteries consisted of participation in the passion, death and resurrection of a God. We are ignorant of the modalities of this participation but one can conjecture that the sufferings, death and resurrection of the God, already known to the neophyte as a myth or as authentic history, were communicated to him during initiations, in an 'experimental' manner. The meaning and finality of the Mysteries were the transmutation of man. By experience of initiatory death and resurrection, the

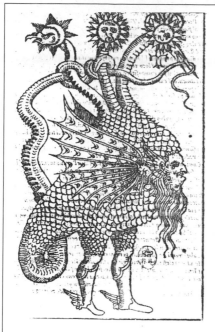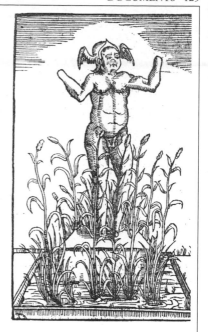

Two illustrations from Gian Battista Nazari, *Della trasmutazione metallica*, 1572: left, a monster representing original matter; right, Mercury with his hands amputated.

initiate changed his mode of being (he became 'immortal').

Now the dramatic spectacle of the 'sufferings,' 'death' and 'resurrection' of matter is very strongly borne out in the very beginnings of Graeco-Egyptian alchemistical literature. Transmutation, the *magnum opus* which culminated in the Philosopher's Stone, is achieved by causing matter to pass through four phases, named, from the colours taken on by the ingredients: *melanosis* (black), *leukosis* (white), *xanthosis* (yellow) and *iosis* (red). Black (the *nigredo* of medieval writers) symbolizes death, and we shall return again to this alchemical mystery. But it is important to empha-

size that the four phases of the *opus* are already mentioned in the pseudo-Democritean *Physika kai Mystika* (fragment preserved by Zosimos)—that is, in the first alchemical writing proper (second to first century BC). With innumerable variations, the four (or five) phases of the work (*nigredo, albedo, citrinitas, rubedo,* sometimes *viriditas,* sometimes *cauda pavonis*) are retained throughout the whole history of Arabian Western alchemy.

Mircea Eliade,
The Forge and the Crucible, 1956,
translated by Stephen Corrin, 1962

Alchemy in literature

The rich symbolism and mystery of alchemy has always attracted writers, whether they wish to capture the essence of the esoteric in images of a hidden and secret science, or to use alchemy as a metaphor for spiritual quests.

The medieval English poet Geoffrey Chaucer (c. 1342–1400) had a somewhat skeptical attitude toward alchemists.

'…That this quiksilver I wol mortifye
Right in youre sighte anon, withouten
 lie,
And make it as good silver and as fin
As ther is any in youre purs or myn,
Or elleswhere, and make it malliable;
And elles holdeth me fals and unable
Amonges folk for evere to appeere.
I have a poudre heer, that coste me
 deere,
Shal make al good, for it is cause of al
My konning, which that I yow shewen
 shal.
Voide youre man, and lat him be
 theroute,
And shette the dore, whils we been
 aboute
Oure privetee, that no man us espie,
Whils that we werke in this
 philosophie.'
 Al as he bad fulfilled was in dede…
This preest, at this cursed chanons
 bidding,
Upon the fir anon sette this thing,
And blew the fir, and bisied him ful
 faste.
And this chanoun into the crosselet
 caste
A poudre, noot I wherof that it was
Ymaad, outher of chalk, outher of glas,
Or somwhat elles, was nat worth a
 flye,
To blinde with this preest; and bad him
 hie
The coles for to couchen al above
The crosselet. 'For in tokening I thee
 love,'
Quod this chanoun, 'thine owene
 handes two
Shul werche al thing which that shal
 heer be do.'

'Graunt mercy,' quod the preest, and
was ful glad,
And couched coles as that the chanoun
had.
And while he bisy was, this feendly
wrecche,
This false chanoun—the foule feend
him fecche—
Out of his bosom took a bechen cole,
In which ful subtilly was maad an
hole,
And therinne put was of silver
lemaille
An ounce, and stopped was, withouten
faille,
This hole with wex, to kepe the lemaille
in.
And understondeth that this false gin
Was nat maad ther, but it was maad
bifore…
He putte this ounce of coper in the
crosselet,
And on the fir as swithe he hath it set,

And caste in poudre, and made the
preest to blowe,
And in his werking for to stoupe lowe,
As he dide er,—and al nas but a jape;
Right as him liste, the preest he made
his ape,
And afterward in the ingot he it caste,
And in the panne putte it at the laste
Of water, and in he putte his owene
hand,
And in his sleve (as ye biforen-hand
Herde me telle) he hadde a silver teyne.
He slily took it out, this cursed heyne,
Unwiting this preest of his false craft,
And in the pannes botme he hath it
laft;
And in the water rombled to and fro…

> Geoffrey Chaucer,
> *The Canon's Yeoman's Tale*
> from *The Canterbury Tales,*
> after 1386

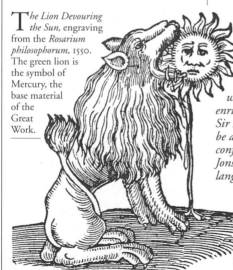

T*he Lion Devouring
the Sun,* engraving
from the *Rosarium
philosophorum,* 1550.
The green lion is
the symbol of
Mercury, the
base material
of the
Great
Work.

*The popularity of alchemy in the
Renaissance made it often the butt of jokes
and satires, in which the alchemist
usually figures as a false medic and
mountebank. One of the most
famous of these is Ben Jonson's
play* The Alchemist, *in which
Subtle, an alchemist and
charlatan, gulls a variety of people
who want to use his arcane skills to
enrich themselves. Among these dupes is
Sir Epicure Mammon, himself a would-
be alchemist. Dol and Face are Subtle's
confederates; Surly is a skeptical gamester.
Jonson delights in lampooning the arcane
language of alchemy.*

DOL.…I have spied Sir
 Epicure Mammon…
SUBTLE. O, I did look
 for him with the
sun's rising: 'marvel he could
sleep.

This is the day I am to perfect for him
The magisterium, our great work, the
 stone;
And yield it, made, into his hands: of
 which
He has, this month, talk'd as he were
 possess'd.
And now he's dealing pieces on't away.
Methinks I see him entering ordinaries,
Dispensing for the pox, and plaguy
 houses,
Reaching his dose, walking Moor-fields
 for lepers,
And offering citizens' wives pomander
 bracelets,
As his preservative, made of the elixir…
I see no end of his labours. He will
 make
Nature asham'd of her long sleep: when
 art,
Who's but a step-dame, shall do more
 than she
In her best love to mankind, ever
 could:
If his dream last, he'll turn the age to
 gold…
MAMMON. There within, sir, are the
 golden mines,
Great Solomon's Ophir! he was sailing
 to't,
Three years, but we have reach'd it in
 ten months.
This is the day, wherein, to all my
 friends,
I will pronounce the happy word, BE
 RICH;…
Where is my Subtle, there! Within, ho!
FACE. [*Within.*] Sir, he'll come to you by
 and by.…
MAMMON. This night, I'll change
All that is metal, in my house, to gold:
And, early in the morning, will I send
To all the plumbers and the pewterers,
And buy their tin and lead up; and to
 Lothbury for all the copper.

SURLY. What, and turn that too?
MAMMON. Yes, and I'll purchase
 Devonshire, and Cornwall, and
 make them perfect Indies! you
 admire now?
SURLY. No, faith.
MAMMON. But when you see th' effects
 of the Great Medicine,
Of which one part projected on a
 hundred
Of Mercury, or Venus, or the moon,
Shall turn it to as many of the sun;
Nay, to a thousand, so ad infinitum:
You will believe me.
SURLY. Yes, when I see't, I will…
MAMMON. Do you think I fable with
 you? I assure you,
He that has once the flower of the sun,
The perfect ruby, which we call elixir,
Not only can do that, but, by its
 virtue,
Can confer honour, love, respect, long
 life;
Give safety, valour, yea, and victory,
To whom he will. In eight and twenty
 days,
I'll make an old man of fourscore, a
 child.
SURLY. No doubt; he's that already.
MAMMON. Nay, I mean, restore his
 years, renew him, like an eagle,
To the fifth age; make him get sons and
 daughters,
Young giants; as our philosophers have
 done,
The ancient patriarchs, afore the flood,
But taking, once a week, on a knife's
 point,
The quantity of a grain of mustard
 of it;
Become stout Marses, and beget young
 Cupids.
…'Tis the secret
Of nature naturized 'gainst all
 infections,

Cures all diseases coming of all causes;
A month's grief in a day, a year's in
 twelve;
And, of what age soever, in a month:
Past all the doses of your drugging
 doctors.
I'll undertake, withall, to fright the
 plague
Out of the kingdom in three months.
SURLY. And I'll be bound…
MAMMON. You are incredulous.
SURLY. Faith I have a humour, I would
 not willingly be gull'd. Your stone
Cannot transmute me.
MAMMON.…Will you believe antiquity?
 Records?
I'll shew you a book where Moses and
 his sister,
And Solomon have written of the art;
Ay, and a treatise penn'd by Adam—
SURLY. How!
MAMMON. Of the philosopher's stone,
 and in High Dutch.
SURLY. Did Adam write, sir, in High
 Dutch?
MAMMON. He did; which proves it was
 the primitive tongue.…

<div align="right">Ben Jonson,

The Alchemist,

from Acts I and II,

1610</div>

Writing in the mid-20th century, Lawrence Durrell infused his exotic Alexandria Quartet *novels with many kinds of esotericism and arcane knowledge. In this passage from the fourth novel,* Clea, *one of his characters describes participating in alchemical research.*

[I have met] a defrocked Italian monk, who describes himself as a Rosicrucian and an alchemist. He lived here among a mountain of masonic manuscripts—

some of very great age—which he was in the process of studying. It was he who first convinced me that this line of enquiry was (despite some disagreeable aspects) concerned with increasing man's interior hold on himself, on the domains which lie unexplored within him; the comparison with everyday science is not fallacious, for the form of this enquiry is based as firmly on method—only with different premises!… Our friendship ripened into a partnership. But it was many months before he introduced me to yet another strange, indeed formidable figure who was also dabbling in these matters. This was an Austrian Baron who lived in a large mansion inland and who was busy (no, do not laugh) on the obscure problem which we once discussed—is it in *De Natura Rerum*? I think it is—the *generatio homunculi*?…

Now this Baron…had *actually produced* ten homunculi which he called his 'prophesying spirits.' They were preserved in the huge glass canisters which they use hereabouts for washing olives or to preserve fruit, and they lived in water. They stood on a long oaken rack in his studio or laboratory. They were produced or 'patterned,' to use his own expression, in the course of five weeks of intense labour of thought and ritual. They were exquisitely beautiful and mysterious objects, floating there like sea-horses. They consisted of a king, a queen, a knight, a monk, a nun, an architect, a miner, a seraph, and finally a blue spirit and a red one! They dangled lazily in these stout glass jars… All the bottles, by the way, were heavily sealed with oxbladders and wax bearing the imprint of a magic seal. But when the Baron

tapped with his fingernail on the bottles and repeated some words in Hebrew the water clouded and began to turn red and blue respectively. The homunculi began to show their faces, to develop cloudily like a photographic print, gradually increasing in size. The blue spirit was as beautiful as any angel, but the red wore a truly terrifying expression...

Paracelsus has said: 'Innumerable are the *Egos* of man; in him are angels and devils, heaven and hell, the whole of the animal creation, the vegetable and mineral kingdoms; and just as the little individual man may be diseased, so the great universal man has his diseases, which manifest themselves as the ills which affect humanity as a whole. Upon this fact is based the prediction of future events.' And so, my dear friend, I have chosen the Dark Path towards my own light.

<div align="right">

Lawrence Durrell,
Clea,
1960

</div>

Marguerite Yourcenar evokes both the world of the 16th century in which her fictional alchemist lives and the nature of his quest—half spiritual, half scientific. Here, he meditates on the meaning of the Great Work.

There were moments when he trembled, as if on the verge of a transmutation: some particle of gold appeared to be born within the crucible of the human brain; yet the result was but an equivalence, as in those fraudulent experiments wherein Court alchemists try to prove to their royal clients that they have found something, although the gold at the base of the alembic proves to be only that of an ordinary ducat, long passed from hand to hand, and put there by the charlatan before the heating began. He knew now that ideas die, like men; in the course of half a century he had witnessed the decline of several generations of notions, all falling into dust...

SOLVE ET COAGULA...He knew well what that formula signified, the rupture of established notions, a great crack in the heart of things. As a young clerk he had read in Nicolas Flamel the full description of the *opus nigrum,* of that attempt at dissolution and calcination of forms which is the first but most difficult part of the Great Work. The operation would come of itself, regardless of one's desire, so Don Blas de Vela had often solemnly assured him, once the necessary conditions had been fulfilled. The student has seized upon these precepts, which seemed to him to have come from some

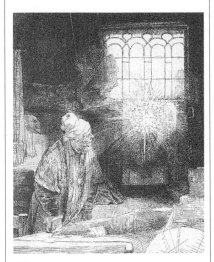

Rembrandt's image of Faust, 1652.

illuminating, if sinister, book of magic, and had pondered them hard. In those early days he had mistaken this whole alchemical process of separation and reduction (so dangerous that hermetic philosophers spoke of it only in veiled terms, and so arduous that whole lifetimes were consumed, most of them in vain, to accomplish it) for what was mere easy rebellion. Later on, rejecting the trumpery in all those teachings, vague dreams as ancient as human illusion itself, and retaining from his alchemist masters only certain practical recipes, he had chosen to dissolve and coagulate matter in the strict sense of experimentation with the body of things. Now the two branches of the curve, the metaphysical and the pragmatic, were meeting; the *mors philosophica* had been accomplished: the operator, burned by the acids of his own research, had become both subject and object, both the fragile alembic and the black precipitate at its base; the experiment that he had thought to confine within the limits of the laboratory had extended itself to every human experience.

Did it follow, then, that the subsequent phases of the alchemical quest might prove to be other than dream, and that one day he would come to know also the ascetic purity of the White Phase of the Great Work, and finally the joint triumph of mind and senses which characterizes the Red Phase, the glorious conclusion? From the depth of the fissure an alluring Chimaera was rising. Zeno's answer was now an audacious "Yes," just as once he had boldly said "No."

Marguerite Yourcenar,
The Abyss, 1968,
translated by Grace Frick

In The Alchymist's Journal, *The novelist Evan S. Connell evokes the voice of the Renaissance alchemist Paracelsus, and then provides imagined commentaries on him by a physician, a historian, and others. Here a student of the master records his impressions.*

That he knew the constituents of the Philosopher's Stone seems undeniable, describing it as unlike rough stone nor any sort of gamaheus, except by puissant resistance to the activities of fire. All claim it resembles gold—inconceivably pure gold—being simultaneously immanent and incombustible with a delicate aspect. Neither gypsum nor galena nor hematite nor malachite nor potash nor alum nor sulfur nor any recognizable element may be detected, because it is sweet to the taste and in-dwelling, fragrant and unctuous and positive, therefore it must be fundamental. Many define it as consensitive with art, spiritual, tenuous, penetrative, indissolubly restorative, by such virtues urging lesser metals toward consummation. Yet to say of it that it is materiate or incorporate would negate its value. Except for a human soul the Stone appears our noblest agent of restitution, which is why at the time of this beneficence all mankind shall clap hands in unison. So said the master. But the days of hermetic chymists are differently reckoned, being more or less than common days…

Evan S. Connell,
The Alchymist's Journal,
1991

Further Reading

PRINCIPAL COMPENDIA OF TREATISES AND MANUSCRIPTS

Ars chemica, Strasbourg, 1566. Includes:

Hermes Trismegistus (attr.), *Tractatus aureus*, pp. 7–31.

Tabula Smaragdina (*Emerald Tablet*), pp. 32–33.

Artis auriferae, 2 vols., Basel, 1572, 1593. Includes:

Aurora consurgens, 15th century, vol. 1, pp. 185–246.

Maria Prophetissa, *Practica…in artem alchimicam*, vol. 1, pp. 319–24; English trans. as *The Practise of Mary the Prophetesse*, in British Library ms. Sloane 3641,

ff. 1–8, London.

Morienus Romanus, *Sermo de transmutatione metallorum*, vol. 2, pp. 7–54.

Arnau de Vilanova, *Rosarium philosophorum*, vol. 2, pp. 204–384.

Turba philosophorum, [12th century], vol. 1, pp. 1–139.

Bibliographie des Sciences psychiques et occultes, 3 vols., Paris, 1912. Ed. A. L. Caillet.

Bibliotheca chemica curiosa, ed. Joannes Jacobus Mangetus (Jean-Jacques Manget), 2 vols., Geneva, 1702. Includes:

Altus, *Mutus liber in quo tamen tota Philosophica hermetica*

figuris hieroglyphicis depingitur, [1677].

Ficino, Marsilio [Marsilius Ficinus], *Liber de arte chemica* [*Corpus hermeticum*, Latin trans. of Greek text], vol. 2, pp. 172–83.

Hermes Trismegistus (attrib.), *De alchymia*; *Tractatus aureus de lapidis physici secreto*; *Testamentum*, vol. 1.

Khalid, *Liber secretorum alchemiae*; *Liber trium verborum*, vol. 2.

Rupecissa, Johannes de, *Liber lucis*, [1394], vol. 2.

Senior [Zadith ben Hamuel], *De chemia Senioris antiquissimi philosophi libellus*, vol. 2.

Bibliothèque des philosophes chimiques, 4 vols., Paris, 1740–54. Ed. Jean Maugin de Richenbourg and Guillaume [William] Salmon. Includes:

Abraham [Portaleone of Mantua], *Préceptes et instructions du père Abraham à son fils contenant la vraie sagesse hermétique*, vol. 4, pp. 552–65.

Flamel, Nicolas, *Explication des figures hiéroglyphiques du cimetière des SS. Innocents à Paris*, vol. 2, p. 195.

Gobineau de Montluisant, *Enigmes et hiéroglyphes physiques qui sont au grand portail de l'église cathédrale et métropolitaine de Notre-*

Dame de Paris, vol. 4, pp. 307–93.

Morienus [Romanus], *Entretien du roi Calid et du philosophe; Sur le Magistère d'Hermès*, vol. 2, pp. 56–11.

Turba philosophorum, or *Assembly of the Alchemical Philosophers*, [12th century], vol. 2, pp. 1–55.

Zachaire, D., *Opuscule de la philosophie naturelle des métaux*, vol. 2, pp. 447–558.

Collectanea chemica: Select Treatises of Alchemy & Hermetic Philosophy. Ed. A. E. Waite, 1893; *Collectanea Chemica: Being Certain Select Treatises on Alchemy and Hermetic Medicine*, 1963.

Collection des anciens alchimistes grecs, 3 vols., Paris, 1887–88. Ed. Marcellin Berthelot and Charles Ruelle.

Deutsches theatrum chemicum [*Biblioteca chemica*, Nuremberg, 1727–35], 3 vols., Berlin, 1728–30. Ed. Friedrich Roth-Scholtz. Includes:

Albertus Magnus (attr.), *Epistel oder Send-Brief des Kaysers Alexandri…*, vol. 3, 1752, pp. 227–44.

Histoire de la philosophie hermétique accompagnée d'un catalogue raisonné des écrivains de cette science, N. Lenglet-Dufresnoy, ed., Paris, 1742, The Hague, 1742. Includes:

Philalethes, *Introitus apertus ad occlusum regis Palatium* [Amsterdam, 1667];

GLORIA MVNDI.
Alias,
PARADYSI TABVLA.
HOC EST:
VERA PRISCÆ SCIENTIÆ DE-
scriptio, quam Adam ab ipso Deo didicit:
Noë, Abraham & Salomo, tamquam sum-
morum divinorum donorum vnum, vsur-
parunt.omnies sapientes, omnibus tempo-
ribus,pro totius Mundi Thesauro ha-
buerunt,& solis plis post sese
reliquerunt.

Nimirum
DE LAPIDE PHILOSOPHICO.
2. *Pet.* 5. *v.* 5.
*Verum nequitia ergo ignorare volunt, quod coelum
olim etiam fuerit, quodque terra ex: & in
aqua,per Dei verbum constiterint.*

ANNO M.DC.XXV.

The title page of a 1625 alchemical treatise.

The title page of the first edition of Michael Maier's *Atalanta fugiens*.

L'Entrée ouverte au palais fermé du roi, pp. 121–273; *L'Épître de Georges Ripley à Edouard IV, roi d'Angleterre, expliquée par Eyrénée Philalète,* pp. 206–341.

Musaeum hermeticum, Frankfurt, 1625, 1678; modern ed. A. E. Waite. Includes:

Lambsprinck, *De lapide philosophico,* [1599].

Maier, Michael, *Tripus aureus,* [1618].

Valentine, Basil, *Les douze Clefs de philosophie de frère Basile Valentin, religieux de l'Ordre de Saint Benoist, traictant*

de la vraye medecine metallique. L'Azoth ou le moyen de faire l'or caché des philosophes, [1624].

Theatrum chemicum, 6 vols., Strasbourg, 1602, 1613, 1622, 1661. Includes:

Claveus, Gasto Duclo, called, *Apologia argyropoeiae et chrysopoeiae,* [1590], vol. 2; *De recta et vera ratione prognignendi lapidis philosophici,* vol. 4.

Dee, John, *Monas hieroglyphica,* vol. 2.

Khalid, *Liber secretorum alchemiae,* vol. 6.

Theatrum chemicum britannicum, Elias

Ashmole, ed., London, 1652, repr. 1999. Includes:

Norton, Thomas, *The Ordinall of Alchymy, written, in verse, by Thomas Norton, of Bristoll,* [c. 1480–90].

SELECTED OTHER TREATISES

Abraham (Portaleone of Mantua), *De auro dialogi tres,* Venice, 1584.

Agricola, Georgius, *De re metallica,* Basel, 1556; trans. by Herbert Clark Hoover and Lou Henry Hoover, 1950.

Albertus Magnus, *Book of Minerals,* trans. by Dorothy Wyckoff, 1967.

Andreae, Johann Valentin, *Chymische Hochzeit Christiani Rosenkreutz,* 1459, Strasbourg, 1616; *The Chymical Wedding of Christian Rosenkreuz,* trans. by Jon Valentine, 1981.

Aquinas, Saint Thomas (attr.), *Secreta alchemiae magnalia...,* Leyden, 1592.

Arnauld, Pierre, Sieur de la Chevallerie, *Philosophie naturelle de trois anciens philosophes renommés: Artéphius, Flamel et Synesius, traitant de l'art occulte et de la transmutation métallique,* Paris, 1682.

Arnau de Vilanova [Arnaldus de Villanova], *Thesaurus thesaurorum seu Rosarius philosophorum ac omnium secretorum maximum secretum...,* Frankfurt, 1603.

———, *Haec sunt opera Arbnaldi de Villanova quae in hoc volumine continentur,* Lyon, 1504.

Artephius, *Artefii Clavis majoris sapientæ,* Strasbourg, 1699.

Aurach de Argentina, Giorgius, (attr.), *Pretiosissimum donum Dei,* c. 1475[?], in British Library ms. Harley 6453, London.

Aurora consurgens, 15th century; ed. Marie-Louise von Franz, 1966.

Avicenna (Ibn Sīnā), *Opera medica (Canon of Medicine),* Rome, 1593, Latin trans. of *Qanun fi-l-tibb,* 11th century.

Bacon, Roger, *The Mirror of Alchemy, Composed by the Thrice-Famous and Learned Fryer Roger Bacon* (1597), ed. Stanton J. Linden, 1992.

———, *Lettre sur les prodiges de la nature et de l'art,* trans. and comm. by A. Poisson, Paris, 1893.

Balinas (attr.), *Kitab Sirr al-khaliqa wa santat al-tabia* (*Book of the Secret of Creation and the Art of Nature,* also called the *Book of Causes,* c. 650.

Benedictus, *Liber aureus de principiis naturae et artis,* Frankfurt, 1630.

Buch der Heiligen Dreifaltigkeit (*Book of the Holy Trinity*), 1415.

Christophe de Paris, *Elucidarium, seu Artis transmutatoriæ metallorum summa major de opere vegetabili et minerali,* Paris, 1649.

Claveus, Gasto Duclo, called, *Philosophia chemica,* Lyon, 1612.

Clopinel, Jean de Meung, called, *De la transformation métallique; La*

Fontaine des amoureux de science; Les Remonstrances de nature à l'alchymiste errant, Paris, 1561.

————, *Le miroir d'alquimie de Jean de Mehun, Avec La table d'émeraude d'Hermes Trismegiste, et Le commentaire de l'Ortulain sur la dite table, Plus Le livre de secrets d'alchymie de Calib Iiuf,* Paris, 1612.

Colleson, Jean, *L'Idée parfaite de la philosophie hermétique,* Paris, 1719.

Cyliani, *Hermès dévoilé,* Paris, 1832; *Hermes Unveiled,* trans. by Partick J. Smith, 1997.

Dee, John, *Monas hieroglyphica,* Antwerp, 1564.

de Ferrare, Pierre Le Bon de Lombardie, called *De secreto omnium secretorum Dei dono,* Venice, 1546.

Espagnet, Jean d', *Enchiridion physicae restitutae,* Paris, 1608; trans. as *The Hermetic Arcanum,* 1988.

————, *La Philosophie naturelle restablie en sa pureté...,* Paris, 1651.

Ficino, Marsilio [Marsilius Ficinus], *An Unknown Concerning the Chymicall Art,* 1518, in British Library ms. Sloane 3638, London.

Flamel, Nicolas, *Livre des figures hiéroglyphiques,* in ms. français 14765 [supp. fr. 680], 1772–73, BNF, Paris; trans. as *His Expo-sition of the Hieroglyphical Figures,* 1994.

Glauber, J. R., *Opera chymica,* Frankfurt, 1658.

Grosparmy, N., Valois, Nicolas, and Vicot, *Abrégé de théorique, Trésor des trésors, Les Cinq livres,* ms. 2516 (166, S.A.F.), 17th century, Bibliothèque de l'Arsenal, Paris.

Helias, *Speculum alchimiae,* Frankfurt, 1614.

Helvetius, *Vitulus aureus,* Amsterdam, 1667.

Hermes Trismegistus, *His Divine Pymander in Seventeen Books,* John Everard, trans., London, 1657 [English trans. of Ficino's edition of the *Corpus hermeticum*].

Hesteau, Clovis, sieur de Nuysement [Jacques Nuysement], *Sal, Lumen, & Spiritus Mundi Philosophici: Or, The dawning of the Day, discovered by the beams of Light,* London, 1657.

————, *Traittez de l'harmonie et constitution générale du vray sel,* Paris, 1620.

Jābir ibn Hayyān [Geber], *De alchimia libri tres,* Strasbourg, 1529.

————, *Summa perfectionis magisterii,* Venice(?), 1473.

Kelly, Edward (attr.), *Tractatus duo egregii, de lapide philosophorum, una cum teatro astronomiae terrestri (The Theater of*

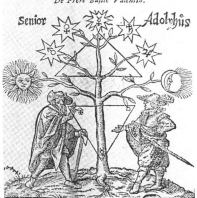

Title pages of early editions of two works by Basil Valentine.

Terrestrial Astronomy), Hamburg, 1678.

Kitab Sirr al-Asar, c. AD 800, trans. from the Arabic into Latin by Johannes Hispalensis, c. 1140; probable source of the *Emerald Tablet.*

Khunrath, Heinrich, *Amphitheatrum sapientae aeternae* (*Amphitheater of Eternal Wisdom*), Hamburg(?), 1595(?).

Lacinius, Janus [Giovanni Lacinio], *Praeciosa ac nobilissima artis chymiae collectanea de occultissimo ac praeciosissimo philosophorum lapide,* Nuremberg, 1554; trans. as *A Form and Method of Perfecting Base Metals,* 1983.

Libois, Etienne, *L'Encyclopédie des dieux et des héros sortis des qualités des quatre éléments et de leur quintessence,* Paris, 1773.

Lully, Raymond [Ramón Lull], *Codicillus seu Vade mecum, in quo fontes alchimicae artis ac philosophiae reconditioris uberrimè traduntur,* Rouen, 1651.

————, *De alchimia opuscula quae seguuntur,* Nuremberg, 1546.

Maier, Michael, *Atalanta fugiens,* with prints by J. T. de Bry, Oppenheim, 1618; English trans. in British Library ms. Sloane 3645, London, and Yale University Mellon ms. 48, New Haven; modern ed. by Joscelyn Godwin, 1989.

————, *Symbola aureae mensae duodecim nationum,* Frankfurt, 1617.

————, *Viatorium hoc est*

de montibus planetarum septem seu metallorum, Rouen, 1651.

————, *Cantilenae intellectuales de phoenice redivivo,* Paris, 1758.

Norton, Samuel, *Mercurius redivivus,* Frankfurt, 1630.

Paracelsus, Theophrastus Bombast von Hohenheim, called, *Bücher und Schriften des edlen, hochgelehreten und bewehrten philosophi medici,* Basel, 10 vols., 1589–91; trans. as *The Hermetic And Alchemical Writings of Paracelsus,* ed. by A. E. Waite, 1967.

Pernety, Dom Antoine-Joseph, *Dictionnaire mytho-hermétique,* Paris, 1758.

————, *Treatise on the Great Art,* 1976.

Philalethes, Eirenaeus, *Alchemical works: Eireneus Philalethes,* 1994.

————, *Secrets Reveal'd: An Open Entrance to the Closed Palace of the King,* trans. by Patrick Smith, 1998. *See also* George Starkey.

Pico della Mirandola, Giovanni Francesco, *De auro libri tres,* Venice, 1586.

Pontanus, *De lapide philosophico,* Frankfurt, 1614.

————, *Epistola de igne philosophorum,* ms. 19969, BNF, Paris.

Qasim al-'Iraqi, Muhammad Ibn Ahmed Abu'l, *Kitab Al-ilm Al-Muktasab Fi Zira'at Adhahab, The Book of Knowledge Acquired Concerning the Cultivation*

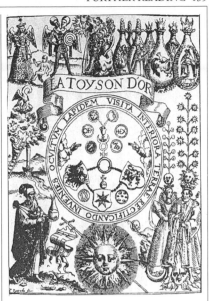

An allegorical image from the 1612 *Toyson d'or* of Salomon Trismosin.

of Gold, 14th century, trans. by E. J. Holmyard, 1991.

Rhasis [Abubekr ben Zacharia], *Abubecri rhazae opera,* Basel, 1544.

Ripley, George, *The Compound of Alchymy, Or the Ancient Hidden Art of Archemie,* London, 1591.

————, *Opuscula quaedam chemica,* Frankfurt, 1614.

Rupescissa, Johannes de, Jean de Roquetaillade, called, *De consideratione quintae essentie rerum omnium, opus sanè egregium* (*The Book of Quintessence or the Fifth Being: That is to Say Mortal Heaven*), Basel, 1561.

Sendivogius, Michael, *Novum lumen chymicum,* Paris, 1608; *A New Light of Alchymie: Taken Out of the Fountaine of Nature, and Manuall Experience,* London, 1650.

————, *Traicté du soufre et du sel,* The Hague, 1639; *A Philosophical Account of Nature in general, and of the generation of the three principles of nature, viz. mercury, sulphur, and salt, out of the four elements,* trans. by John Digby, London, 1722.

————, *Le cosmopolite; ou, la nouvelle lumière chymique,* Paris, 1723; *The New Chemical Light,* vol. 1, *Treatise of Mercury,* vol. 2, *Treatise of Sulphur,*

trans. by Patrick J. Smith, 1998.

Starkey, George, [Eirenaeus Philoponus Philaletha], *Liquor alchahest, or a discourse of that immortal disolvent of Paracelsus and Helmont...*, London, 1675; repr. *The Secret of the Immortal Liquor Called Alkahest*, 1984.

———, *Pyrotechny asserted and illustrated, to be the surest and safest means for arts triumph over natures infirmities, Being a full and free discovery of the medicinal mysteries studiously concealed by all artists, and only discoverable by fire. With an appendix concerning the nature, preparation, and vertue of several specifick medicaments, which are noble and succedaneous to the great arcana*, London, 1658.

Stolcius, D., *Viridarium Chymicum*, Frankfurt, 1624.

Trismosin, Salomon, *La Toyson d'or ou la fleur des trésors*, Paris, 1612; *Splendor Solis: Alchemical treatises*, ed. by Julius Kohn, London, 1990.

Valentine, Basil, *Les douze Clefs de philosophie de frère Basile Valentin, religieux de l'Ordre de Saint Benoist, traictant de la vraye medecine metallique*.

L'Azoth ou le moyen de faire l'or caché des philosophes, Paris, 1624.

———, *Triumph-Wagen Antimonii...*, Leipzig, 1604; *The Triumphal Chariot of Antimony*, trans. by A. E. Waite, 1893.

———, *Révélation des mystères et des teintures essentielles des sept métaux et de leurs vertus médecinales*, Paris, 1645; *Of natural & supernatural Things. Also, Of the first Tincture, Root, and Spirit of Metals and Minerals*, London, 1670.

———, *The Last Will and Testament of Basil Valentine, Monke of the Order of St. Bennet. Which being alone, He hid under a Table of Marble, behind the High-Altar of the Cathedral Church, in the Imperial City of Erford*, London, 1670.

MODERN CRITICAL TEXTS

Abraham, Lyndy, *A Dictionary of Alchemical Imagery*, 1999.

Albertus, Frater, *An Alchemist's Handbook*, 1976.

Alleau, René, *History of Occult Sciences*, n.d.

Anon., *Meditations on the Tarot*, 1985.

Aromatico, Andrea, *Liber lucis: Giovanni da Rupescissa e la tradizione alchemica*, Milan, 1996.

Barbault, Armand. *Gold of a Thousand Mornings*, 1975.

Berthelot, Marcellin, *Les Origines de l'alchimie*, 1885.

Blavatsky, H. P. *Isis Unveiled*, 1972.

Brann, N. L., "George Ripley and the Abbot Trithemius," *Ambix*, vol. 26, no. 3, pp. 212–20, 1979.

Burckhardt, Titus, *Alchemy: Science of the Cosmos, Science of the Soul*, 1967.

Burland, Cottie A., *The Arts of the Alchemists*, 1968.

Canseliet, Eugène, *Deux Logis alchimiques*, Paris, 1945.

———, *Alchimie: Etudes diverses de symbolisme hermétique et de pratiques philosophales*, Paris, 1964.

Coudert, Allison, *Alchemy: The Philosopher's Stone*, 1980.

Davis, Tenny L., "The Emerald Tablet of Hermes Tristmegistus: Three Latin Versions which Were Current among Later Alchemists," *Journal of Chemical Education*, vol. 3, no. 8, pp. 863–75, 1926.

———, *Roger Bacon's Letter Concerning the Marvellous Power of Art and of Nature and Concerning the Nullity of Magic*, 1999.

de Jong, H. M. E., *Michael Maier's Atlanta Fugiens: Sources of an Alchemical Book of Emblems*, 1969.

Dobbs, Betty Jo Teeter, *Alchemical Death and Resurrection: The Significance of Alchemy in the Age of Newton*, Washington, 1990.

———, *The Foundations of Newton's Alchemy, or*

AUREUM SECULUM REDIVIVUM,

QVOD NVNC ITERVM APPARVIT, suaviter floruit, & odoriferum aureumque semen peperit.

Carum pretiosumque illud semen ómnibus veræ Sapientiæ & Doctrinæ Filiis monstrat & relevat

HINRICUS MADATHANUS.

FRANCOFURTI, Apud HERMANNUM à SANDE. M DC LXXVII.

This title page of Henricus Madathanus's allegory, *Aureum seculum redivivum*, written in 1621, displays an alchemical emblem of a cross surmounting a circle over a hexagram.

"The Hunting of the Greene Lyone," 1975.

———, The Janus Face of Genius: The Role of Alchemy in Newton's Thought, 1991.

Eamon, William, Science and the Secrets of Nature: Books of Secrets in Medieval and Early Modern Culture, 1994.

Eliade, Mircea, The Forge and the Crucible: The Origins and Structures of Alchemy, [1956], 1962.

———, "Metallurgy, Magic and Alchemy," Cahiers de Zalmoxis, Paris, 1938.

Evola, Julius, The Hermetic Tradition: Symbols and Teachings of the Royal Art, trans. by E. E. Rehmus, 1995.

Fabricius, Johannes, Alchemy: The Medieval Alchemists and their Royal Art, 1976.

Fulcanelli (Jean-Julien Champagne?), Le Mystère des cathédrales et l'interprétation des symboles ésotériques du Grand Oeuvre, 1926.

———, The Dwellings of the Philosophers (Les Demeures philosophales et le symbolisme hermétique dans ses rapports avec l'art sacré et l'ésotérisme du Grand Oeuvre, 1930), trans. by Brigitte Donvez and Lionel Perrin, 1999.

Haeffner, Mark, The Dictionary of Alchemy: From Maria Prophetissa to Isaac Newton London Aquarian, 1991.

Holmyard, E. J., Alchemy, 1957.

———, The Great Chemists, 1928.

———, The Works of Geber, 1928.

Jung, Carl Gustav, Alchemical Studies, 1968.

———, Psychology and Alchemy, [1944], trans. by R. F. C. Hull, 1968.

Junius, Manfred M., The Practical Handbook of Plant Alchemy, 1985.

Klossowski de Rola, Stanislas, Alchemy: The Secret Art, 1973.

———, The Golden Game.

Lindsay, Jack, The Origins of Alchemy in Graeco-Roman Egypt, 1970.

Maclean, Adam, The Crowning of Nature, 1980.

———, A Commentary on the Mutus Liber, 1982.

Manzalaoui, M. A., Secretum Secretorum: Nine English Versions, 1977.

Merkel, Ingrid, and Debus, Allen G., Hermeticism and the Renaissance: Intellectual History and the Occult in Early Modern Europe, 1988.

Needham, Joseph, Science and Civilisation in China, vol. 5, part 4: Spagyrical Discovery and Invention: Apparatus, Theories, and Gifts, 1980.

Pritchard, Alan, Alchemy: A Bibliography of English Language Writings, 1980.

Read, John, From Alchemy to Chemistry, 1961.

———, Prelude to Chemistry, 1936.

Redgrove, S., Alchemy: Ancient and Modern, 1911.

Roob, A., The Hermetic Museum: Alchemy and Mysticism, 1997.

Sadoul, J., Alchemists and Gold, 1972.

Schumaker, Wayne, The Occult Sciences in the Renaissance, 1972.

Shah, Idries, The Sufis, 1977.

Stapleton, H. E., Lewis, G. L, Taylor, F. Sherwood, "The Sayings of Hermes quoted in the Ma Al-Waraqi of Ibn Umail," Ambix, vol. 3, pp. 69–90, 1949.

Steele, R. and Singer, D. W., "The Emerald Table," Proceedings of the Royal Society of Medicine, vol. 21, 1928.

Stillman, J. M., The Story of Alchemy and Early Chemistry, 1960.

Taylor, F. Sherwood, The Alchemists: Founders of Modern Chemistry, 1951.

Thorndike, L., History of Magic and Experimental Science, 6 vols., 1923–41.

Webster, Charles. From Paracelsus to Newton: Magic and the Making of Modern Science, 1982.

Wirth, Oswald, Le Symbolisme hermétique, Paris, 1936.

Witten, Lawrence, and Pachella, Richard, Alchemy and the Occult: A Catalogue of Manuscripts from the Collection of Paul and Mary Mellon Given to Yale University Library, 2 vols, 1977.

Yates, Frances A., The Rosicrucian Enlightenment, London, 1972.

———, Giordano Bruno and the Hermetic Tradition, 1964.

Zolla, Elemire, Le Meraviglie della natura:

Introduzione all'alchimia, 1991.

JOURNALS

Ambix: Journal of the Society for the Study of Alchemy and early Chemistry, London, 1937–.

Atlantis, Archéologie scientifique et traditionnelle, Vincennes, 1926–.

Cahiers de l'Hermétisme, Paris, 1977–.

Cauda Pavonis: Studies in Hermeticism, Pullman, Washington, 1982–.

Chrysopoeia: revue publiée par la Société d'Etude de l'Histoire de l'Alchimie, Paris, 1987–.

Chymia: Annual Studies in the History of Chemistry, Philadelphia, 1956–67.

Isis: Journal of the History of Science Society, Baltimore, 1912–.

Journal of the Alchemical Society, ed. H. Stanley Redgrove, 3 vols., 1913–15.

La Tour Saint-Jacques, Paris, 1955–62.

List of Illustrations

Key: *a*=above, *b*=below, *l*=left, *r*=right, *c*=center
Abbreviations:
BNF=Bibliothèque Nationale de France

Front cover: Details from pages 26–27, 56l, 62a, 62b–63.
Spine: Detail from page 58.
Back cover: Detail from page 18b.
1–9 Illuminations in Salomon Trismosin (supposed teacher of Paracelsus), *Tractatus alchymicae germanick splendor solis,* German alchemical ms., [1532], 1589.
1 Two philosophers at the doorway of the alchemical temple, with alchemy's *arma artis,* or coat of arms, bearing the signs of sun and moon, Kupferstichkabinett, Berlin.
2 A practitioner bears the alchemical vessel, whose banner declares, in Latin, "Let us seek the four elements of nature," British Library, London.
3 The queen, with her foot on the earth, faces the king, standing upon fire. Above them are Luna and Sol, moon and sun. The queen's ribbon is inscribed, "the milk of the heroine"; the king's reads, "coagulate the masculine." The scene represents a stage in the alchemical transmutation of materials called the *conjunctio,* or union, Kupferstichkabinett, Berlin.
4 The king, in the form of the black Ethiopian, emerges from water, greeted by the queen, British Library, London.
5 The glass retort at the

center of some of these images is the hermetically sealed vessel of the alchemical Great Work, represented in symbolic form in seven stages. In this stage it contains the crowned bird, whose three heads indicate that matter has been sublimated three times, and is in a gaseous state. The vessel is surrounded by a scene of war and destruction; at top, the war god Mars rides his chariot pulled by wolves. A text explains that heat purifies the unclean, Kupferstichkabinett, Berlin.
6 The philosophical tree, or Tree of Knowledge, is also the tree of life, and represents the alchemical Great Work. At left is the ancient Roman hero Aeneas, from the epic Roman poem of Virgil. His son Silvius, on the ladder, offers him a branch of the tree as he prepares to pass through the fires of the underworld, Kupferstichkabinett, Berlin.
7 The alchemical vessel is surrounded by a scene of celebration. It contains the peacock, ancient symbol of rebirth or reincarnation, and also, because of its multicolored tail, a reference to a "brightly colored" phase of the Great Work, or to the change from one phase to another. At top is the goddess Venus, representing the pleasures of the senses, Kupferstichkabinett, Berlin.
8 Within the alchemical vessel, the lunar queen represents the white work, called the Albedo, and the stage of solidification of

matter. She presides over a scene of the arts and sciences, including music and astronomy. At top is the god Mercury, bringing the dawn, Kupferstichkabinett, Berlin.
9 The red sun rises over a city and landscape. Aurora, or dawn, indicates the moment when light and dark are not yet separated into two distinct entities, Kupferstichkabinett, Berlin.
11 Carl Spitzweg (1808–85), *The Alchemist,* Staatsgalerie, Stuttgart.
12 Hermes Trismegistus, detail of an inlaid marble pavement in the cathedral, Siena.
13 The Caduceus of Hermes, detail of an illustration in Denis Molinier, *Alchimie de Flamel, écritte en chiffres, en douze clefs,* ms. français 14765 [supp. fr. 680], 1772–73, BNF, Paris.
14l Copy of a tablet from the Library of Assurbanipal in Nineveh, in R. Campbell Thompson, *Assyrian Chemistry,* 1925. The original tablet is in the British Museum.
14r, 15b Details of page 15a.
15a Illustration in Qasim al'Iraqi, *Kitab al-Aqalim as-Sab'ah,* 18th-century edition, British Library, London.
16l Detail of page 16r–17l.
16r–17l Goldsmiths and Blacksmiths, wall painting, Tomb of Rekhmira, Thebes, Valley of the Kings, 18th Dynasty.
17r Page in the *Synosius,* Greek treatise on alchemy, ms. copied by Theodore Pelecanos, ms. grec 2327, 1478, BNF, Paris.

18a Detail of *The Cosmos,* hand-colored engraving in Michael Maier, *Atalanta fugiens,* Oppenheim, 1618, BNF, Paris.
18b Detail of *The Cosmos,* miniature in *Les Très riches heures du Duc de Berry,* c. 1416, Musée Condé, Chantilly.
19 The Universe as It Was Represented around 1520, color illustration in Camille Flammarion, *L'Atmosphère et la météorologie populaire,* Paris, 1888.
20–21l Nature-Alchemy, illustration in the *Tractatus alchemici,* 15th century, British Library, London.
21r Jehan Perréal, *Nature's Remonstrances to the Errant Alchemist,* illustration in *Les Remonstances de nature à l'alchimiste errant,* 1516, Musée Marmottan, Paris.
22l, 22r–23l Details of *Hermes Trismegistus and the Precursor Symbols,* engraving in Michael Maier, *Symbola aureae mensae duodecim nationum,* Frankfurt, 1617.
23r Giorgione, *The Three Philosophers,* oil on canvas, c. 1506, Kunsthistorisches Museum, Gemäldegalerie, Vienna.
23b The Travels of Democritus in Egypt, engraving in Michael Maier, *Symbola aureae mensae duodecim nationum,* Frankfurt, 1617.
24 Diagram of the Cosmos, illustration in Lambsprinck (*The Book of Lambspring,* first published under the title *De lapide philosophico,* Prague, 1599), *Musaeum hermeticum,* Frankfurt,

The title page of an edition of the *Musaeum hermeticum* published in Frankfurt in 1678.

Index

Photograph Credits

Text Credits

Andrea Aromatico is a historian, art historian,
and expert in Hermetic iconography and esotericism.
He is a manager of the historical archives for the
Region of Pesaro-Urbino, Italy. He is the author of
*Ottaviano Ubaldini: Il principe filosofo e la rocca di
Sassocovaro* (1993), *Medicamenti, pozioni e incantesimi
del Ricetario Magico Urbinate* (1993), and *Liber Lucis:
Giovanni da Rupescissa e la tradizione alchemica* (1996).

*To my parents, for who I am;
to Paolo, an exacting master, for what I know:
Thank you for having believed in me, I will not disappoint you.*

Translated from the French by Jack Hawkes

For Harry N. Abrams, Inc.
Editor: Eve Sinaiko
Typographic designers: Elissa Ichiyasu, Tina Thompson
Cover designer: Dana Sloan
Text permissions: Barbara Lyons

Library of Congress Cataloging-in-Publication Data

Aromatico, Andrea.
 [Alchimie. English]
 Alchemy : the great secret / by Andrea Aromatico.
 p. cm. — (Discoveries)
 Includes bibliographical references.
 ISBN 0–8109–2889–2 (pbk.)
 1. Alchemy. I. Title. II. Series : Discoveries (New York, N.Y.)
QD26.A69 2000
540'.1'12—dc21 99–37575

Printed and bound in Italy by Editoriale Lloyd, Trieste